NEW EPSON COMPLETE G
TO DIGITAL PRINTING

NEW EPSON COMPLETE GUIDE
TO DIGITAL PRINTING

By Rob Sheppard

LARK BOOKS

A Division of Sterling Publishing Co., Inc.

New York / London

Editor: Kara Helmkamp
Book Design: Ginger Graziano
Cover Design: Thom Gaines
Assistant Editor: Matt Paden
Editorial Assistance: Danielle Andes

Library of Congress Cataloging-in-Publication Data

Sheppard, Rob.
 New Epson complete guide to digital printing / Rob Sheppard.
 p. cm.
 Includes index.
 ISBN-13: 978-1-60059-263-8 (trade pbk. : alk. paper)
 ISBN-10: 1-60059-263-5 (trade pbk. : alk. paper)
 1. Computer printers. 2. Digital printing. 3. Image processing--Digital
techniques. 4. Images, Photographic--Data processing. I. Epson (Firm) II.
Title. III. Title: Epson complete guide to digital printing.
 TK7887.7.S482 2008
 686.2--dc22
 2007040393

10 9 8 7 6 5 4

Published by Lark Books, A Division of
Sterling Publishing Co., Inc.
387 Park Avenue South, New York, N.Y. 10016

Distributed in Canada by Sterling Publishing,
c/o Canadian Manda Group, 165 Dufferin Street
Toronto, Ontario, Canada M6K 3H6

Distributed in the United Kingdom by GMC Distribution Services,
Castle Place, 166 High Street, Lewes, East Sussex, England BN7 1XU

Distributed in Australia by Capricorn Link (Australia) Pty Ltd.,
P.O. Box 704, Windsor, NSW 2756 Australia

If you have questions or comments about this book,
please contact:
Lark Books
67 Broadway, Asheville, NC 28801
(828) 253-0467

Manufactured in China
All rights reserved

ISBN 13: 978-1-60059-263-8

For information about custom editions, special sales, premium and
corporate purchases, please contact Sterling Special Sales
Department at 800-805-5489 or specialsales@sterlingpub.com.

TABLE OF CONTENTS

INTRODUCTION

The concept for the original *Epson Complete Guide to Digital Printing* grew out of Epson's desire in the early 2000s to make the process of printing digital photos easier and more understandable for everyone. As editor of *PCPhoto* magazine at the time, I was asked to help and with Lark Books published the first edition in 2003. We have revised and updated the title two times in the past five years. The three editions sold extremely well, reinforcing Epson's belief that people want a thorough guide to help them create beautiful pictures.

Because of ever-changing technology and new, even better, products from Epson, we felt that today's digital photographers needed a new, more relevant guide. The digital world is really amazing when you

consider that, by its fifth birthday, a successful photo book could be so outdated that it required a rewrite.

Digital photography has exploded over the last few years and ink jet printing has been a big part of that boom. In this same timeframe, amateur and professional photographers alike have gone from being wary of new technology to totally embracing it, abandoning traditional analog photography altogether. The speed of this conversion has even amazed visionaries.

Today's multi-megapixel digital SLR (D-SLR) cameras are capable of providing files for stunning ink jet prints not only equal to but in most cases better than any created with 35mm film. Some recently released D-SLRs rival the image quality of medium-format film cameras. Anyone who says that digital can't equal film quality has not shot and printed with the equipment that is now available on the market.

The ink jet printers available today are incredible feats of engineering. Epson printers offer stunning photo-quality prints that far surpass standard silver-based photographs. I have always admired Epson printers and am honored to work with Epson because of its tradition of supporting photographers and its reputation as a market leader in photo-quality printers. It was Epson that inadvertently was the inspiration for Werner Publishing to create *PCPhoto* magazine nearly ten years ago. What happened is an interesting story: A group

from Werner Publishing had gone to a major computer trade show where printer manufacturers had big booths highlighting their equipment. Most emphasized their business capabilities and how well their printers reproduced text. Epson, however, exhibited pictures printed with their best ink jet printer at the time. While this was before the introduction of their first photo printer, the Epson Stylus Photo EX, Epson had decided to exhibit printer quality using photos, and they looked great! Good as they were, the prints weren't equal to the quality of standard photo enlargements of the time, but they clearly hinted at a future when fine photographic prints would be created with computers and ink jet printers. We were all impressed, especially our publisher, who responded by kick-starting a new digital magazine—*PCPhoto*. At this time, no other photo

publication was devoted to helping photographers understand the new imaging technologies. In the same way, no other company was as devoted to promoting digital printing to photographers as Epson.

While this book is designed to provide information about Epson printers and their technology, mostly this book is about the enjoyment of creating great prints. I hope it will get you on the right track to successful printing and help you avoid disappointments. In the past five years, I have spent a lot of time "figuring" printing out so I can explain it better and the results are in this book. For more information about digital photography, my books, and workshops check out my website, www.robsheppardphoto.com.

A good print respects the original image and communicates the intent of the photographer.

CHAPTER 1

What is a Good Print?

What is a good print of your photo? How can you make a better one? This book explores these common questions more fully in later chapters, but to start, we really need to agree on what exactly is a good print.

I have heard a lot of people answer that a good print matches the monitor and a better one matches it better! While having a properly calibrated monitor is critical to the process of getting a good print, simply saying a print must match a monitor in order to be good is very misleading in the quest of getting a better print.

A Print is Different than a Monitor

To make a better print, I believe it is important to consider that a print is physically a very different thing than the image on the monitor.

A monitor, ultimately, can only serve as a guide for what a print should be. I am not saying that the monitor is unimportant or that it has no relation to the print. The monitor is vital and it greatly affects how you print. This is why you must calibrate it and do everything you can to get as good an image as possible on that monitor. View the monitor as an aid to getting a great print, but not as the standard for that print.

Matching the Monitor

Let's take the idea of a print being different than a monitor a little further. Why should the only criteria of a good print be that it matches the monitor? What if the image on the monitor really isn't right for a print? What if the monitor displays a great image but that same image as a print doesn't work? How can that be?

A monitor gives a feeling of looking into an image, while a print gives the feeling of looking at an image. Those are psychologically quite different impressions that strongly affect how we perceive an image. And while digital frames are becoming increasingly popular, they are physically small and not identical to a monitor either.

All this doesn't even address the idea of actually matching colors and tones between the monitor and the print. You certainly do want to have a printing process that is consistent and predictable, which allows your print to have a direct relationship to the colors and tones on the monitor. This is what monitor calibration gives you.

But a print cannot match the monitor precisely (again, they are two completely different display technologies). No matter what you do, including such things as "soft proofing," a monitor with glowing RGB colors will never look the same as a paper print made with reflective inks in a different set of colors. And as you print, you will discover that an image that looks good on the monitor may offer a very different impression on paper, even though the two seem to match.

Size of an Image Affects Its Appearance

We also tend to look at a monitor and a print from different distances. Monitors are viewed from a pretty constant distance. Prints, however, are seen

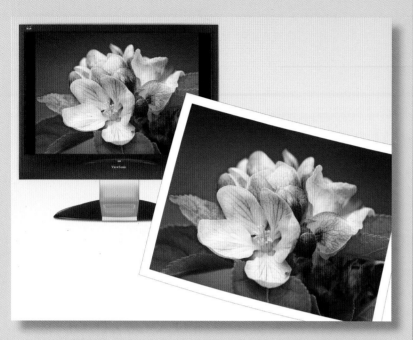

A print is not the same as the image you see on a monitor. Rarely does someone want to see the image on the monitor to compare it—the print must stand on its own.

Monitor calibration is vital for a consistent and predictable printing workflow. It doesn't guarantee good prints, but it increases the accuracy of the process.

by people from a variety of distances, which are somewhat determined by their dimensions.

The size of an image has a major influence on how you react to it. Everyone responds very differently to a 4 x 6-inch (10 x 15 cm) print than they do to an 11 x 14-inch (28 x 36 cm) print of the same subject. First, people don't take a smaller print as seriously as a larger print. Second, few people study a 4 x 6 print as closely as they would something larger.

You can make an on-screen image close to an 8 x 10 inch (20 x 25 cm) print size and smaller, but for larger photos, most people don't have the monitor space to display an image at actual printed size. Even if you have a very large monitor, you won't fit a 12 x 18 inch (30 x 46 cm) vertical full size on your screen. Even if you could, your viewing distance would be skewed—and you are accustomed to being up close and personal with that monitor in ways that people are not with a print. Finally, if you are printing large exhibition-size prints, you'll never get that size on your monitor in any orientation.

The Printing Tradition

To really get the most from your printing—and to truly get a better print—we need to go back to the true craftsmen of traditional black-and-white photographic printing like Ansel Adams and W. Eugene Smith. The stunning prints created by these photographers often kept them in the darkroom for days. They honored the print as something very special.

In fact, there is a story about W. Eugene Smith from his early days of working for Life magazine that illustrates his skill. He had shot an assignment, and then turned his film into the Life photo lab as he left for another assignment. (As his career developed, he refused to allow anyone to touch his images other than himself.)

The film was processed and printed. The lab folks were no hacks; they knew how to make a good print. The prints went to the editors, and they picked a few for use.

The size of a print greatly affects its appearance and thus the viewer's perception of the image.

Smith returned and wondered why certain photos had not been chosen. The editors said the shots were not that compelling. Smith took the negatives, went into the darkroom, and printed the images the way he felt they should be printed.

The astonished editors suddenly realized why Smith considered those images so important—he brought them to life in the darkroom. However, he did not accomplish this through any technological trickery. He simply knew photographic technology and chemistry very well; he made them work for him, rather than limiting him. And he put a lot of time into making his prints.

That brings up an interesting side note. A lot of photographers today say they don't want to be bothered with spending time in front of the computer—they'd rather be shooting. Photographers like Smith and Adams spent a great deal of time in the darkroom, even though they probably would have rather been shooting too. But they so

Printmaking is a craft—the more you practice, the better you get. Examine your prints, not the monitor, to truly master this craft.

honored the print as the ultimate form of photographic expression that they were willing to invest the time.

Unfortunately, Smith did not write books about his processes and techniques, but Adams did. Adams' books, especially *The Negative* and *The Print* (published by Little, Brown, & Co.) are invaluable for the digital photographer who wants to make better prints. You don't need to read the sections on chemistry, which have no bearing on the digital process—just reading the extensive captions about the photographs will tell you a lot about working on an image to make it look its best.

Craft and the Print

A good print comes from craft, not simply science and technology. Making an exceptional print ultimately comes from more than how much color management is involved, what printers are used, and how Photoshop is set up. It is what is in the print and how it is expressed that matters. To paraphrase master photographer Jay Maisel—it's not how much technology you use for a print, but what you put into the print that matters.

Even the most subtle of differences can change how the viewer reacts to a print.

Of course, the technology is important. But craft means mastering the technology for your creative purpose, not letting technology master you.

One way this can happen is to consider, as Ansel Adams did, the first print you make to be a proof or work print. In *The Print*, Adams says, "Arriving at a 'fine print' involves proceeding through various stages of 'work prints' until you arrive at a rendering that looks and feels right in all ways." He also says, "The differences between the various stages of work prints leading to the fine print are often subtle, and require meticulous craftsmanship."

Further on in that book, he says something that absolutely applies to digital printing, "The technical issues of printing must not be allowed to overwhelm the aesthetic purposes: the final photographic statement should ... transcend the mechanics employed."

The mechanics Adams talks about in the book can be translated to digital technology today. The photograph must be more than the tools of Photoshop, the megapixels of a camera, and the size and expense of a monitor. A print should be more than a technical exercise of matching a monitor so that you create something beautiful that stands on its own. No one admiring your print is going to ask you to show it on a monitor for comparison.

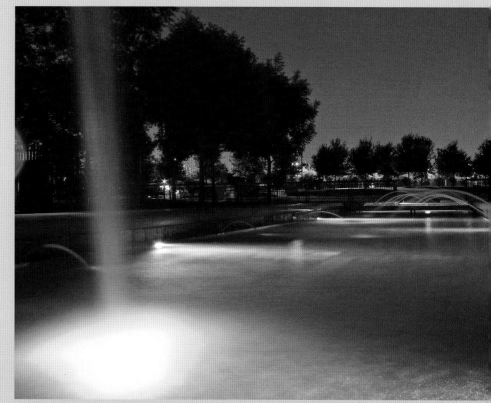

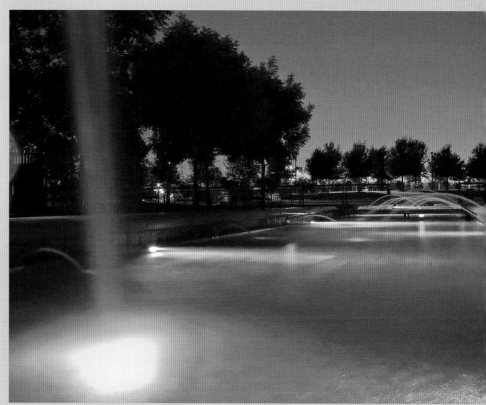

Some cynics consider work prints a waste of time, but though the first print might look good it will rarely be perfect. Examine the print, make adjustments, and avoid the idea that the first print must be the best.

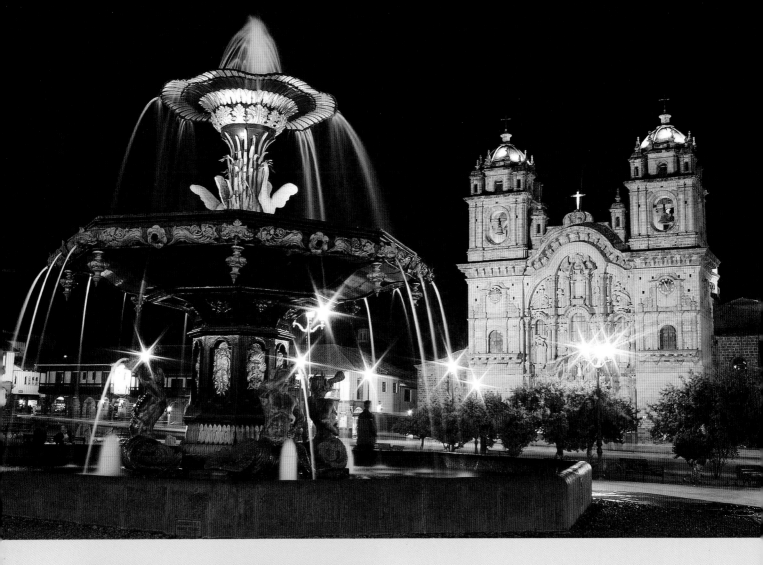

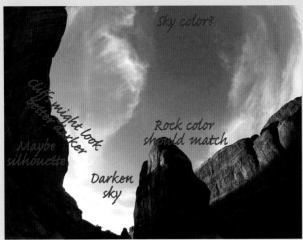

Traditional darkroom masters like Ansel Adams often made notes directly on their work print. This is a valuable practice in the digital printing workflow as well.

Not too long ago, I had a discussion about digital printing with John Sexton, a master black-and-white photographer and one of the finest printers working today. Sexton was also Ansel Adams' last assistant and printed many of Adams' photographs. Sexton says that one of the reasons photographers don't get the best prints from digital processes is that they don't print early enough.

What he means is that they try to do everything in the computer, watch the monitor for changes, and then attempt to match the print to the monitor. This causes problems, as described above, because a print is not the same thing as the image on the monitor. You need to see what an image looks like as a print to truly evaluate what it needs to be a good print. Thus, you need to evaluate the image from looking at work prints.

Now, it is possible that your first work print will look great—in that case, the work print will be the same as

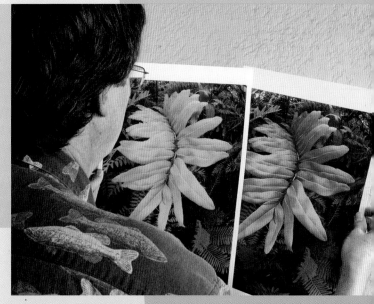

✳ TIP... Make a work print. Your first print of an image should always be a work print. This will allow you to evaluate your image on paper, and will help you determine what needs to be done to the image to improve the print. Look at this print carefully and decide what adjustments, if any, are needed to make it work better as a print, not just as a better match to the monitor.

the final print. With experience, you will learn to read the monitor so you can better anticipate how a print will look, which will mean achieving a good print faster.

Work prints, though, do mean making more prints, but if you really want the best print possible from your photo, it is worth it. It is actually far faster and cheaper to do multiple work prints with a "digital darkroom" than in the traditional wet darkroom, especially when you consider color printing.

For example, I did a workshop recently where a student printed a wonderful image of a captive bobcat that matched the monitor pretty well. There was no question that he had a good print. But we had discussed going beyond the good print to produce a better photograph, so he did some print tests. He found that warming up the image made the fur on the animal really come alive, which was a great improvement over his original print.

Also, more than once I have made a print and discovered flaws in the photo that were merely minor distractions on my monitor. These became more noticeable when the image was viewed as a print. For example, in a favorite landscape photo of mine, there were dark areas in the water and rock, which I brought up to balance with the brightness in the rest of the image. It looked fine on my monitor, but it wasn't until I made the print that I discovered noise in that area.

Comparing prints teaches you how to look at a print, evaluate it on a paper medium rather than the digital monitor medium, and understand what makes the best print.

I did not see the noise on the monitor for a couple of reasons. One, the monitor was smaller than the print, and two, the experience of seeing the glowing colors on the monitor distracted me from really seeing the problem of the noise (even when the image was enlarged). After making the print, I looked at the image on the monitor and I could definitely see the problem. I fixed it by changing how I brightened the dark areas and using noise reduction software (I used Kodak ASF Digital GEM because it is quick and simple, and works well for this sort of thing).

Another time, I spent a bit of time adjusting a miniature landscape of moss and lichens to bring the best out of the image. But my work print revealed a balance problem. The left side was brighter due to the way the scene curved over some rocks and caught the light.

This bright edge was distracting in the print.

Ansel Adams always warned photographers about bright edges taking the viewer's eye off the main subject in the composition and even off the print itself. So, I darkened that edge and made another work print. Finally, I ended up making some 12 x 16 inch (30 x 40 cm) prints that I loved.

Should I have noticed this on the monitor? The image certainly did have some extra brightness on the left side. This was visible on the monitor, but I really did not think it was a problem then. However, when I darkened the edge after looking at the test print, the photo on the monitor looked even better because the tonalities were more in balance. Essentially, I matched the monitor to the print! Sometimes it takes a print to see an image as it really is.

Maybe in the future, sheet-based prints as we know them won't exist. Maybe we'll just hang monitors on the walls for all of our photographs and the images will change constantly. But for now, we use prints. And prints are not the same as monitors, no matter what we do, so they need to be evaluated as prints in order to get the most from them.

What is a Bad Print?

What we consider to be a good print is, ultimately, highly subjective. However, there is no question that there are certain objective criteria that will keep a print out of the "good" category. Here are ten flaws that degrade the quality of a print:

❋ **Poor or inappropriate focus**–this comes from not shooting the image right in the first place.

❋ **Incorrect exposure**–a too bright or too dark image will annoy viewers. People tend to dismiss or be very critical of images they can't see very well.

❋ **Off color**–one reason Ansel Adams did very little color work was because he did not like the color printing technology that existed in his lifetime. He felt the photos often looked like a television set out of adjustment. Viewers do not like color casts that don't belong with the subject or the vision of the photographer.

❋ **Garish color**–this is a big issue today. Many photographers want the bright, lively colors they were used to with print film or slides, so they crank up the saturation control. This usually results in garish, out-of-whack colors rather than attractive, bright, and lively ones.

❋ **The wrong size**–some photos just don't blow up well, and thus look bad as big prints. This can be a quality issue (when a photo starts to lose sharpness as it gets big, for example) or a content issue (simple snapshots often can be great at standard print size, but look mediocre when greatly enlarged).

❋ **No blacks**–by this I mean areas of pure, deep black in the photo. Most prints need some areas with pure

There are a number of things that can make a bad print. In the above example, the color of the image is off, the contrast is harsh, and the image is noisy—any of which could affect the print.

This image would likely create printing problems because the highlights are overexposed.

This image could be a good or a bad print, depending on whether the black areas rendered as black on paper and not just the monitor.

A good print stands on its own and fits the vision of the photographer. The subject and scene come alive and draw the viewer's eye.

black or the image will look washed out and weak in color.

✳ **No whites**–if the bright highlights of a scene are not pure white, the image will look dull.

✳ **Distractions**–it is easy to crop a photo, so viewers are often critical of images with distracting "stuff" which doesn't belong around the edges of the composition.

✳ **The wrong paper**–some subjects just don't look right on a glossy paper, for example.

✳ **Poor use of ink jet technology**–this is usually caused by improper setting of the printer driver and/or poor cleaning of the printer head.

What is a Good Print?

A good print doesn't exhibit technical problems such as the ones listed above, and it goes further by offering pleasing composition and tonality. Outstanding prints go even further to affect the viewer and express what the photographer wanted to convey about the subject.

Here are ten ideas about what makes a good (and/or better) print:

✳ **The photo works as a print**–this means taking the print and looking at it as something separate from what you saw on your monitor, your experience in taking the picture, your feelings about the subject, and so forth. You should try to see the print for what it is—as a viewer will see it—isolated from all of that.

✳ **It matches the needs of the photographer**–does the print do what you want it to do? Does it look like how you envisioned it?

✳ **It expresses the vision of the photographer**–a photographer's vision and interpretation of a scene are very important.

✳ **The subject and scene come alive**–it has a "spark," is inspiring, beautiful, or unique.

✳ **It does what it needs to do**–for example, if the print needs to impress a client, it does that. If it needs to be a welcome gift for a relative, it should do that. If it needs to add color and interest to a living room, it does that. If it needs to make a statement about someone or something, it communicates that message. None of these are arbitrary things. They are legitimate, subjective goals for a print.

✳ **It works in the location where it will be displayed**– this can be a very critical issue for a print. A dark print might look great in a bright location, but when put in a dark corner of a room, it loses its appeal. Similarly, a bright print in a dark location can be perfect but may look washed out in a bright spot.

✳ **It is printed at a size that suits the subject and is appropriate for the photograph's original**

quality—while digital cameras offer capabilities of making outstanding large prints, not every photo will enlarge well. You must recognize when the photo has been enlarged beyond its inherent quality potential.

❋ **The print has a quality appropriate to the setting or point from which it will be viewed**—print quality is very subjective, but it is strongly affected by how an image is perceived. A print that is high behind a receptionist, in a location where it can never be seen up close, may have a different quality than one that dominates a living room and everyone sees up close.

❋ **Matches the needs of the viewer**—this is a variable criterion. Sometimes photographers want to surprise a viewer and challenge them with an image that goes beyond their expectations. However, viewers do have certain expectations about a print that will be based on the place it is displayed and its context.

❋ **Will last an appropriate length of time**—if a print is of family members and needs to be preserved for generations, the print should do that. If it is a simple proof for a pro to get additional work, it does not need the same archival life (in fact, it might be better in this case to have a shorter life).

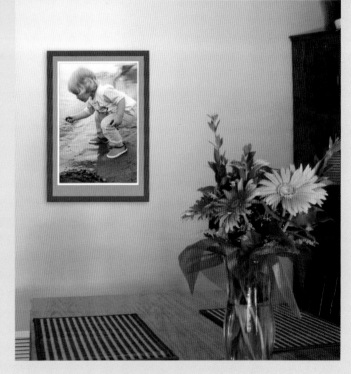

A good print will complement its surroundings, especially if the image is appropriate to that setting.

The ideal printer varies
from person to person
and depends on a
photographer's needs.

Selecting a Printer

The ink jet printers of today are pretty amazing, especially when you consider that ten years ago nothing like them existed—photo-quality ink jet printers were just entering the marketplace. These early printers were slow and the images they produced faded in about six months. Yet, they showed a promise that there would eventually be something better for photographic printing than a traditional darkroom.

Today, that promise has been realized. Ink jet printers—found everywhere from drugstores to high-quality, fine-art professional print labs—produce outstanding photo prints. The traditional wet darkroom has nearly disappeared, especially for color work. The advantages of making a great print without toxic chemicals, sensitive chemistry, total darkness, and spending a lot of time waiting are huge!

Today's ink jet printer offerings include a wealth of options from Epson, from lunchbox-size personal printers to large-format printers that will fill a small room (but also make wonderful poster prints). To choose the best one for you, you need to understand how ink jet printers work and what their features mean. Then you can decide what makes a difference to you.

Ink Jet Technology

With an ink jet printer, ink is sprayed in tiny droplets onto the paper in a distinct pattern to make all the tones and colors you expect to see in a photograph. This is a sophisticated, remarkable process. Epson has spent a great deal of time and money on the algorithms (computer instructions in the program) and hardware needed to do this—just consider what is involved: Those tiny droplets of ink must be continuously applied from a moving printing head, each droplet laid down accurately in very defined patterns and in the right color mix to create a photo print. That mix is

critical, too. Any pixels that stray from the pattern will be noticed immediately as a print defect.

I have to let you in on a fashionable name for ink jet printing. There are many in the fine art field who turn up their noses at anything other than a giclee (shee-CLAY) print. The joke is that a number of years ago, so the story goes, a printer at a top printing shop decided to do something about the snobbish requests for a "finer" name than ink jet, so he came up with giclee (which just means to spray, in this case, ink). This definitely sounded like some exotic, European technology, which suited the fine-art crowd just fine.

Epson printers lay down the ink droplets in their specified patterns with a unique printing technology—their patented piezo-electric printing head. There are variants of this head depending on the level of printer, the number of inks, etc., but all of them basically work the same, with electrical pulses pushing out the ink from the head to the paper. The printer driver (software) translates the digital data representing a photo with its colors and tones into electrical pulses inside the printer head. These pulses activate specified ink channels, then push out minute ink droplets for precise ink placement on the photo.

Micro piezo technology results in very consistent and precise ink droplets, allowing the printer head to place them extremely accurately—so accurately, that a printer calibrated at the manufacturing plant will keep this calibration as it prints. The printing head changes position as it puts these droplets down on the paper, and the printer moves the paper in small steps beneath it. This builds the photo, row by row, inch by inch.

Thousands of tiny drops of ink are deposited very quickly—especially when you consider they all have to line up exactly right in order to make a photo print. Top photo quality depends on a printer's ability to lay down ink in an exact pattern with precise alignment. Epson pioneered algorithms to produce accurate color with true photo gradations and, to this day, they have a strong reputation for doing this extremely well.

In addition, the resolution of the printer (such as 1440 x 720 or 2880 x 1440 dpi) affects how the ink is applied. While higher resolution (up to a point) can produce more detail in shadows and highlights (two of the toughest areas for a printer), as well as crisper text and fine lines, top photo-quality is not dependent on the highest printer resolution.

Epson printers use advanced algorithms that lay ink onto the page in specific patterns to create high-quality printed photographs. (Printed image © Dan Steinhardt.)

Epson printers use ink dots so small that you cannot see them with the naked eye. With smaller droplets, print quality improves because the printed dots blend better to create smoother tonal gradation. This is more important than resolution.

The droplets themselves come in four distinct colors: cyan, magenta, yellow, and black. All Epson printers have at least these four colors. The Epson six-color, or photo printers, add pale versions of cyan and magenta to improve color tonalities. This technique is especially noticeable in the highlights and in subtle gradations between tones.

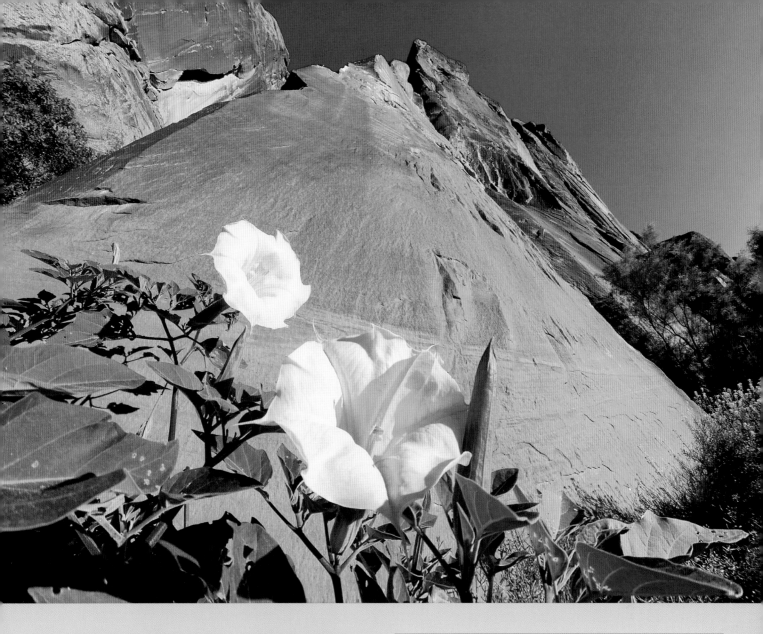

The printers with even more ink colors add different grays (Epson calls them "blacks") to the mix for better neutral tones. This improves a printer's ability to render subtle tonal gradations and create better black-and-white prints. Epson uses all of the ink colors, including black, in photos to gain better shadow detail, purer blacks, and a denser black that makes the overall photo have more brilliance than even a traditional print from your mini-lab.

Epson has also experimented with additional colors in certain printers, and have added red and blue inks to the mix for a wider color gamut. Color gamut is the range of colors that a printer can reproduce in a print. I have found that this wider gamut does result in

More inks and finer droplet sizes enable the printer to create better tonal gradations and color nuances. (Printed image © Dan Steinhardt.)

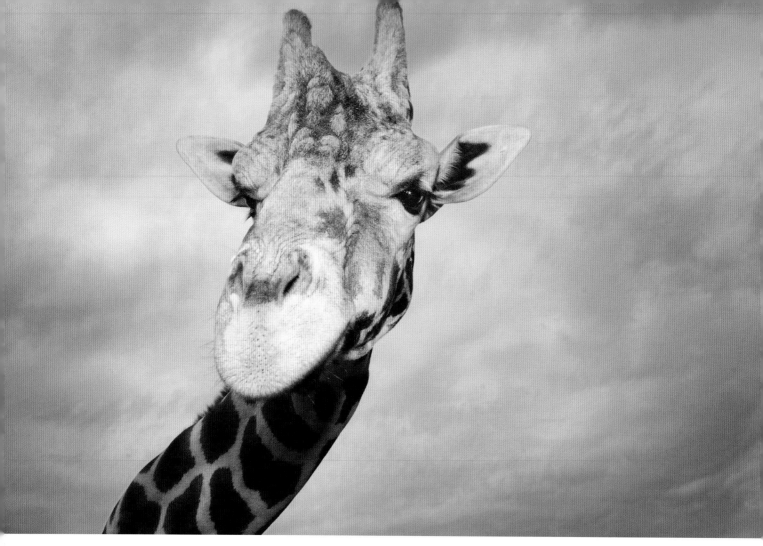

excellent prints, though all of Epson's photo print-
ers do an excellent job with color, even if they
don't have these extra colors. For some photog-
raphers, however, those extra colors can be very
useful in printing certain subjects.

Finally, with some printers ink comes out of the
print head wet and this could be a problem with
such things as smudging. Epson prints, however,
come out of the printer nearly dry because the ink
dries very rapidly. This keeps prints from smearing
and makes them water-resistant, though techni-
cally prints do have a "dry-down" period of up to a
day where the colors lock down (especially blacks)
to their final color and tonalities.

*Small printers, such as the PictureMate, are
increasing in popularity—even with the most seri-
ous photographers—as a second printer for quick
prints directly from the camera or memory card.*

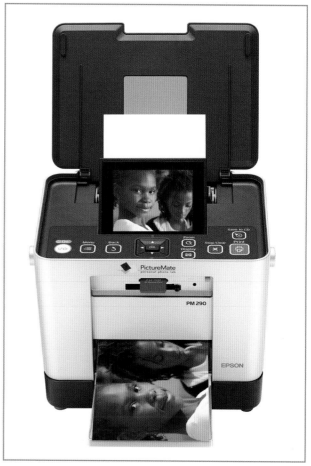

Dyes vs. Pigments

Ink jet printers use two basic types of inks: dyes or pigments. Dyes traditionally offer brighter colors, but are more likely to fade than pigments. Pigments offer more archival printing options, but are more susceptible to print surface damage (pigments sit on top of the print surface). Pigments used to be distinctly less colorful, but that is no longer true. Pigment inks can be quite lively.

For a long time dyes were the only way to print with an ink jet, since they were the only way to get colored ink through the printing head. It was difficult to develop

The overall photo looks like any traditional print, however when you look more closely you see that it is made up of thousands of tiny ink droplets.

pigments that didn't clog the head.

Epson was the first to beat both problems. They developed a dye-based ink with improved fade resistance. They also created a pigmented ink that flowed easily through the print head and produced bright, saturated colors. Epson's latest Radiance printing technology brings a new level of color quality to pigment printing, with optimized color gradation that matches dye-based inks.

Epson's dye-based inks are called Claria inks. These represent the state-of-the-art in dye-based inks, offering brilliant colors and long print life. Epson's pigment-based inks are called Ultrachrome inks and come in several versions. Ultrachrome High-Gloss inks are used in the lower-priced photo printers, while Ultrachrome K3 inks are used in the more advanced printers. All Ultrachrome inks have outstanding color saturation and archival qualities.

Interpreting Printer Specifications

1 Number of Colors

Generally, you will pay for more colors in a printer, though today, Epson photo printers all have at least six inks. Low-priced general-purpose printers, however, come with just the four basic colors: cyan, magenta, yellow, and black. Epson's algorithms get a lot out of those four colors, so you really can get photo-quality images from them. For really fine prints, you need the six- to eight-color photo printers. The extra inks allow for much finer gradations of color and tone. Six-color printers add light cyan and light magenta for much better highlight rendering. Prints look richer with better tonalities,

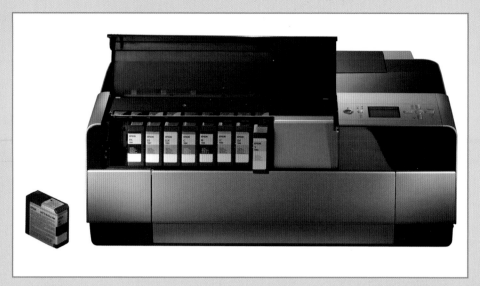

The number of colors a printer uses affects how certain tones and colors—especially light colors—are rendered on the paper.

and dark and light tones are especially enhanced. Eight-color printers add either additional blacks or special colors for an increased color gamut. The added blacks (actually, some are grays, though Epson calls them blacks) give better black-and-white prints.

2 Droplet Size

While there is a lot of hype about resolution in the printer market, a far more important part of the technology is ink droplet size. As droplets decrease in size, tonal gradations improve, colors are more accurate, and the print has more detail in the highlights and shadows. You will occasionally see references that say smaller droplets mean higher resolution; however, this is not true. Droplet size could affect resolution, but the droplets are so small that resolution is not the key effect of size change. Epson printers have some of the smallest droplet sizes on the market—as little as 1-2 picoliters. (A picoliter is a really tiny measurement of a liquid—one-trillionth of a liter.)

Printer Resolution

Resolution is important, but can be confusing. Printer resolution is not the same as image resolution. Image resolution refers to how pixels are arranged in a photo; printer resolution is how ink is applied to the paper. Epson printers are at least 1440 x 720 dpi, which is enough for most photographic purposes. Higher resolutions can slow down printing without much increase in print quality. The 2880 resolution does offer some small improvement in fine gradations in an image, but the difference is hard for most people to see. The high resolutions of 5760 dpi are really unnecessary and can in fact give poorer results. They exist more because competitors have high numbers than for any real photographic purpose. Some photographers do use them—test them and see if the added time needed to make a print is worth the wait.

Speed

Printers continually get faster and price generally increases with speed. In looking at the speed of a printer, however, you need to know several things. Print speed is limited by the computer's processing speed, available RAM, and the type of connection between printer and computer. It takes some computing power to process a file for printing and photos are especially greedy. FireWire and USB 2.0 connections are so similar in speed that you will not find much difference in print speed because of the connection (this may change in the future if FireWire 800 is used more by printers or new connection types become standard).

Also, it is important to note that the industry has no single standard for measuring printer speed so you cannot compare brands easily by looking at published speeds—you can only compare printers within a brand. And keep in mind that the industry has some funny

conventions about the way speeds are marketed. Typically, the advertised fast speeds are for draft or economy mode, which you are unlikely to use with photos. No printer can produce a color photo at speeds of 10 pages per minute. Photos that take several minutes might still be considered fast. Compare fine, best, or photo-quality printing speeds. Epson always includes information on photo-printing speeds with its dedicated photo printers.

Borderless Capabilities

Borderless prints have become standard in the ink jet industry. With a borderless print, the photo comes out of the printer without white borders—no trimming required.

All printers have a maximum print size, dictated by the paper path. This is important to consider when you are choosing a printer.

Most Epson photo printers offer this option. However, borderless printing may only be possible with specific print sizes with a given printer. Even so, Epson offers more borderless choices than other manufacturers.

Paper Path

If you want to print on very thick papers (up to 1.5 mm), be sure the printer you are considering has multiple paper paths. The standard, top-feeding, bent paper path for Epson printers will not accept thick papers. You need a straight-through paper path that allows the printer to print on the paper without having to bend it. A few Epson printers have also offered separate paper paths specifically for fine-art papers.

Print Size

The most popular Epson printers for photographers are those for 13 x 19 inch (33 x 48 cm) prints. These prints are big enough to be impressive, at 11 x 14 and 12 x 18 inches (28 x 36 and 30 x 46 cm), the two standard "large" sizes that these printers can handle. Epson also has a 17 x 22 inch (43 x 56 cm) printer which can produce a 16 x 20 (41 x 51 cm) print with space for matting. Obviously, these large-print units also can print small images as well, including, on some models, the ability to do roll-prints of 4 x 6 (10 x 15 cm). That allows you to print a whole series of images quickly without having to monitor each print. Smaller printers handle the standard 8-1/2 x 11 (22 x 28 cm) paper and smaller. The advantage of a smaller printer is that it is less expensive (Epson has some very inexpensive letter-sized printers), plus they take

Some printers have borderless print capabilities and some don't; another feature to consider when choosing your printer.

up less desk space. Desk space is not insignificant. For big prints, you need a printer that is physically large and heavy. All Epson photo printers will do panoramic prints up to at least 44 inches (112 cm) long, with a smaller dimension that is the width of the printer. The really big roll printers start at 24 inches (61 cm) wide and go up from there.

Epson also makes some specialty printers in the PictureMate series that they call personal photo labs. These small printers are designed to print 4 x 6 (10 x 15 cm) prints directly from a camera or memory card. While not really made for advanced printing, many photographers love to have one around (and I am one of them) so they can quickly make prints for friends and family. You know how that goes—you take some snapshots at a family gathering and promise photos, but never get around to printing them. Pros also like to take these units on location for creating prints that can be given away to people involved in a shoot.

Grouped or Individual Ink Cartridges

8

Today, almost all Epson printers have individual containers for each ink color (the exceptions are some of the lowest-priced printers and the PictureMate printers, which have multiple ink colors per cartridge). Individual cartridges are more economical because you can replace each color as you deplete it. A note on this, however: do not stockpile large numbers of cartridges that won't be used up in a few months. As the cartridges sit, the ink components (especially pigments) will start to stratify, meaning the cartridges won't work properly.

Disk Printing

9

While admittedly not something everyone will use, disk printing is a unique feature available on some Epson printers. If you like burning your own CDs or DVDs,

Individual color cartridges make it easier to replace specific colors as the ink runs out instead of replacing a group of inks.

Pro-model printers are designed for large prints and daily use.

10 Special Needs

You may have some specific needs, such as creating long panoramics, printing on thick papers, or producing prints on a roll (convenient when making a large quantity of 4 x 6 (10 x 15 cm) prints, for example). Check to see if the printer you are considering can do these things.

11 Pro-Printers vs. Consumer Models

Pro-printers are more expensive than consumer models with similar features. Consumer models are designed to sell at a low price and give quality results for that price. Pro-printers are designed for steady, dependable use for nonstop printing day after day. In addition, their tolerances are so tight that a print done one day looks pretty much identical to the same image printed another day. Pro printers offer more control over the final print, including the ability to effectively use paper profiles. Some pro models use large ink tanks to make ink usage more efficient for the heavy user, too. Pros who need such printers will know that immediately from heavy printing needs. Other photographers need to look at specific features, such as black-and-white printing (which is more advanced in Epson's pro-models).

this can be a great feature. It allows you to personalize your disks without messy, hard-to-use, stick-on labels. You can print text, photos, and special designs on them. You can easily make a CD of photos for friends or family, for example, with a really cool look on the disk. CD and DVD slide shows are becoming increasingly popular, and printing the disk makes them more appealing. In addition, many professional photographers like this feature because it means they can customize disks that they are sending to a client.

12 Print Life

Pigment-based inks have more potential for long life than dye-based inks, and Epson has pioneered the use of pigment inks in printers at every price point.

UltraChrome pigment-based inks used in the Epson photo printers provide rich color and long life, and are water, smudge, and light resistant. However, Epson has also developed reasonably long-lived inks in their Claria dye-based ink set used in their lower priced photo printers. In addition, Epson's pigment-based Durabrite inks for general-purpose printers are water, smudge, and light resistant.

13 Connectivity

There are three types of computer-to-printer connections: USB, FireWire, and Ethernet. USB comes in two types, the older USB 1.0 (which no longer can be found in modern computers and printers) and the much faster USB 2.0, which is part of all printers today. To gain the full benefits of USB 2.0, you must have a USB 2.0 port on the computer. FireWire is similar in speed. Both transfer printing data from the computer quite fast. Determining which of these is faster is highly dependent on the computer in use. A number of large Epson printers include Ethernet connections to allow networking capabilities.

14 All-in-One Printers

All-in-one printers incorporate a flatbed scanner in them and minimize the use of desktop space. They can be used to scan photos to the computer or to scan images and print them directly. Various features include the ability to scan prints, slides, and negatives, the potential to print directly from a digital camera's memory card, and even fax capability (on the SOHO models). Epson also includes remarkable "one-touch" software with some of these units for fixing old photos.

15 Direct Printing

Direct printing allows you to print directly from a camera or memory card without going through a computer. This may or may not be important to you. It is a simple way of making quick prints when you have

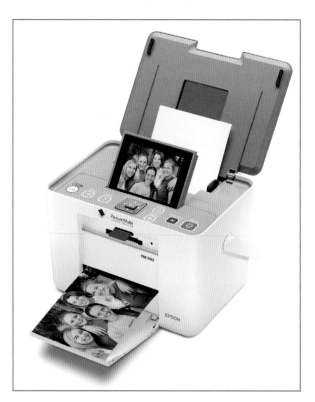

Compact printers typically allow direct printing from memory cards or a camera connection.

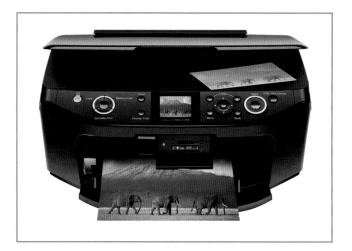

All-in-one printers serve several purposes—scanning and copying old photos, printing from a direct connection such as a memory card, or printing from the computer.

promised them to others, but you don't have a lot of control over the prints. You can print directly with enabled Epson printers in two ways:

1. Pictbridge—a PictBridge compatible camera can be connected directly to the printer for printing.

2. Memory cards—remove the card from the camera, plug it into the appropriate slot on the printer, and start printing.

A LOVE OF PRINTING

Publishing over two thousand photographs through National Geographic has earned Bruce Dale great honors, such as "Magazine Photographer of the Year" and "White House Photographer of the Year." He has photographed in over 75 countries, is a master of Photoshop, and has brought his magic to some incredible pictures in the advertising industry. He continues to do editorial work, but keeps his work in Photoshop very straightforward and limited to traditional darkroom-types of corrections.

Dale loves the control ink jet printing gives him over the final product. For him, the print is truly the key. While a calibrated monitor is important, the print has to live on its own. So with ink jet printing, Dale can adjust the print as much as needed until he likes it. He then saves the final file so he can reprint the same photo in the exact same way later—a huge benefit to digital technology for the printing enthusiast.

He uses his prints for many things, from sending images to clients, to entering competitions, to developing creative techniques, and making gallery prints for sale. His prints can vary in size quite a bit, but most tend to be letter size, 13 x 19 inches (33 x 48.3 cm), or panorama size. Dale loves the ability to make panoramic prints with his Epson printers.

BRUCE DALE

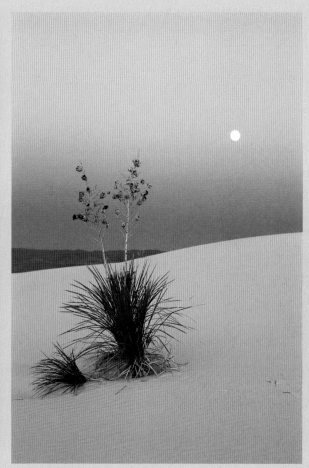

Premium Luster, Velvet Fine Art, Enhanced Matte, and Ultra Smooth Fine Art papers are what you find in Dale's paper cache. The printers that produce his varied prints are the Epson Stylus Pro 3800, 7880, and 9880. He also has a smaller printer, the Epson Stylus Pro R800, for printing text and making CD labels.

For photographers wanting better prints, Dale offers these tips:

1. Make sure you have a good black in the image.

2. Be sure you have a good white.

3. Do all of your burning in LAB mode.

Dale's website is www.brucedale.com.

If you want the best print,
start with the best image
you can produce with
your camera.

A Good Print Starts When You Take the Picture

Think about a dog show. Most people have seen them on TV, or maybe in the cult classic film, *Best in Show*. Dogs are judged for many criteria, from bone structure to poise and so forth. Some owners primp their dogs for hours before the show, doing everything to get the best look, and then work with the dog in specific ways while on the judging floor to try to win the judges' favor.

None of these final efforts would matter, however, if the dog had not gone through the necessary preparatory work ahead of time. The dogs are trained to elicit the proper response while at the show, they are fed and groomed for optimum health and appearance, and handlers are hired for their expertise. But even before all of this, the dogs are selected early on for their potential to become a champion.

What does this have to do with printing, you might ask? Everything. The print is like the judging floor—the best outcome is dependent on many things that have to be done correctly, even perfectly, before that final moment of judging.

A good print starts when you take the picture. This idea is so important that I include it in all of my books and workshops. I am often told, "I can fix it in Photoshop" and I am forced to cringe. Sometimes we do have to fix an image in Photoshop—we make mistakes in shooting, the scene has problems that can't be totally controlled when photographing, and so forth. But the "fix it in Photoshop" philosophy as a main way of working can cause major problems when printing. This issue did not begin with digital photography. When darkrooms were popular, a lot of photographers wanted to "fix it in the darkroom."

The "fix it later" approach does not help make better prints. A less-than-optimal photo will not make a perfect print—it will actually take more work just to get a decent print. I am willing to spend the time required to get a good print, but I don't want to spend more time than is necessary. If I messed up my original photography, I add more time to the image editing process, which is necessary to compensate for my poor technique. It is very disappointing when a photo that you really love will not enlarge to a decent print size because of quality issues related to how the image was shot.

This chapter focuses on things you need to be careful of when taking the picture in order to maximize your photo's potential in print form. Obviously, I can't give you a complete guide to shooting. There are many books on the market that do that, including the *Kodak Guide to Digital Photography*. However, I can point out some specific issues that directly affect a print.

Sharpness

Sharpness problems cannot be fixed in Photoshop. If the picture is not appropriately sharp for the subject when it is taken, nothing can be done to help it.

In a slideshow, you can sometimes get away with less than perfect sharpness. The images come and go quickly, plus they are part of a larger group of images. This is not true for a print. That image stands on its own and people study it closely.

The LCD monitor fools many photographers when the image sharpness might seem fine. But this is because the photo is seen very small. You must enlarge an image to really see the sharpness on the LCD monitor. Know where the enlargement function is on your camera and use it.

In addition, any small image can tolerate less than perfect sharpness. An image printed at a 4 x 6 inches (10.2 x 15.2 cm) may look sharp, but when it is printed at 12 x 18 (30.5 x 45.7 cm), its quality deteriorates.

A big problem I have consistently seen in prints is poor sharpness due to camera movement. At *Outdoor Photographer* magazine, we have judged many photo contests. Many images come in that simply aren't as sharp as they could be. Or they are oversharpened in Photoshop to try to compensate for poor original sharpness—a tactic that never works and just makes the image look ugly.

I have heard the excuse, "I just can't afford a pro lens, so my photos will never be as sharp as they could be." The lens is rarely the problem. Lenses today are very good, even the inexpensive ones. While there certainly are differences between a budget lens and a pro lens, this should not prevent anyone from getting sharp images.

Camera movement during exposure, or camera shake, is the biggest cause of softness in a print. The camera movement causes details to blur. With small amounts of movement, the image loses its brilliance. Brilliance makes a photo snap and sparkle—like the "pro's"

The proper handholding technique greatly improves image sharpness, and thus image quality. Hold the camera with both hands, one supporting the lens, and elbows close to your body.

shot. Brilliance comes from the lens resolving tiny highlights as sharp. Any movement and they blur slightly, making the image look less than its best. A lot of movement, such as trying to handhold a shot at a slow shutter speed, makes the photo look out of focus.

Unless the camera is locked solid to a tripod, camera movement is always a challenge. Shutter speed is a key factor, along with holding the camera correctly. Because so many photographers shoot with autoexposure (and that is a great way to shoot), they often miss seeing what shutter speed the camera is using. This can lead to the camera selecting a shutter speed slower than what should be used when handholding the camera.

I have done tests with many people. Few can handhold a camera with a standard focal length lens (i.e., not a wide-angle or big telephoto focal length) at less than 1/125 second and get the most sharpness from their lens. You can try this yourself. Take a photo of a scene with detail, handholding the camera with a variety of shutter

speeds. Then take the same photo with the camera solidly mounted to a tripod. Compare the images by magnifying the details. You may be surprised at the results.

You can experiment with different focal lengths, too. You will find that you can handhold a wide-angle lens at slower speeds than a telephoto. This is why a wide-to-telephoto zoom looks sharper at wide settings than it does at telephoto focal lengths; you need to shoot the telephoto end with faster shutter speeds. Many photographers find they can shoot a wide-angle lens at speeds as slow as 1/30 second, while they need at least 1/250 second or faster for telephotos.

Depth of Field

Depth of field is the sharpness exhibited throughout the depth of a photo—what is sharp from foreground to background. Landscape photographers typically prefer more of depth of field, while portrait photographers will often go for much less.

Depth of field is greatly affected by print size. As a print gets larger, depth of field decreases. This is actually quite dramatic. Try printing the same image at a 4 x 6 size (10.2 x 15.2 cm), then again at 11 x 14 (27.9 x 35.6 cm) and you will see how the sharpness in depth changes.

TIP... If you want the best print sharpness when shooting at slow shutter speeds, use a tripod.

Appropriate sharpness is critical to print quality. Sharpness has to be made with the camera—it cannot be created in the print.

Focal length–wide-angle lenses give more apparent depth of field, while telephoto lenses give less. (This is related to pure focal length, which results in small digital cameras with very short, or "wide," focal lengths having consistently greater depth of field than bigger digital cameras, such as digital SLRs).

While great depth of field in a landscape can make a terrific print, very narrow depth of field, or selective focus, can also create a dramatic image. Choosing a large aperture, a telephoto lens, and getting reasonably close to your subject can make it pop. However, you must be very careful of the placement of your focal point.

If you want a printed image to have the maximum depth of field, you must shoot with the desired print size in mind. If you think the size of the print will create problems with sharpness, you must be very careful in how you focus. You need to be sure that what needs to be absolutely sharp is that sharp. A common problem emerges when photographing people. A small image may look fine, because its depth of field entirely covers the person's face. But when the image is enlarged, you find the important sharpness falls on the ears but not the eyes, killing a good portrait.

Depth of field is affected by three controls made during the shooting of your subject:

f/stop or aperture–a small aperture (such as f/16) gives a lot of depth of field, while a large aperture (such as f/4) gives minimal depth of field.

Focused distance–If you focus on distant subjects, such as a mountain range, you will have enough depth of field to cover them at nearly any f/stop, while close subjects, such as a flower, will have limited depth of field, even at small apertures.

Exposure

The built-in evaluative exposure meters in today's cameras do an excellent job in most photographic settings.

Overexposure can never be adequately fixed in a print.

The aperture setting and the distance to your focus point are two important elements controlling depth of field in an image.

But there are situations where exposure can be wrong and affect the quality of your print. The key is to recognize when you have an exposure problem and correct it while you are still with your subject.

Exposure problems create several challenges in creating an outstanding print:

✳ **Burned out highlights**—once highlight detail is gone, it is gone. No amount of tricks in Photoshop will bring it back. Of course, some bright highlights don't need detail, such as a bright reflection of light or an edge of a subject in intense sun. But important highlights in your subject must contain detail in the beginning or they will never look right.

✳ **Underexposed dark areas**—these present issues that are opposite to those encountered with the highlights. In an effort to ensure highlight detail, photographers sometimes underexpose the image, resulting in very murky dark areas. These can be brightened in the computer, but two problems generally occur: noise (covered below) and poor color. When color is underexposed, it loses some of its chroma or color quality. When a print is made, these areas will look flat compared to the original scene. You can compensate in Photoshop, but you will never get the nuances of color and tone that would be possible with a better exposure.

✳ **Underexposure**—certain scenes will fool a meter and give you an underexposed image. This often occurs when a really bright area in the scene over-influences the meter. It also occurs with certain cameras that have challenges dealing with certain conditions, such as low-light scenes. This can be corrected to a certain degree in Photoshop or other image processing programs, but you will still encounter color, tone, and noise problems in the print.

✳ **Noise**—modern digital cameras control noise extremely well when the image is exposed properly. But underexposure will dramatically increase noise. As you brighten underexposed areas to make a good

While an image can be adjusted on the computer, it usually results in a lower-quality print. To achieve the best tonality and color in a print, expose the photo as close to perfect as possible.

print, noise will be revealed, which can cause an unpleasant appearance.

The best way to deal with exposure issues with a digital camera is to carefully evaluate your exposures as you shoot. Start with a quick glance at the review image displayed in your LCD monitor after the shot. While this is not a totally accurate view of exposure, it gives a decent indication of the exposure based on how your camera interprets it on the LCD.

Another important tool for evaluating exposure is the histogram. This is a graph of the brightness levels of every pixel in your image. It is described well in many books, and extensive discussion about it is not appropriate for this book. Here are some basic things to look for in a histogram that affect exposure in a way that also affects the print:

✳ **Highlights**–the right side of a histogram represents the highlights. If the graph of information is abruptly cut off at the right side, that means you are losing highlight detail. When detail is cut off, it is said that the highlights are "clipped." This can be a problem if highlight detail is important to the print. Any part of an image that is too bright to be represented in the histogram (i.e., it is past that abrupt cutoff on the right) will not be captured by your camera. Highlight detail that is not captured by your camera cannot be brought back into an image.

✳ **Highlight gap and underexposure**–in an effort to avoid highlight clipping, some photographers deliberately underexpose their image, leaving a gap in the histogram on the right side. This can also be a problem, because it shifts all tonal and color information to the left, resulting in dark areas becoming darker than necessary and color information being lost. Even though these areas may be recovered in Photoshop, tonality and color will not print with the same quality that a properly exposed image (i.e., no gap at the right) will have.

Histograms show the range of tones in an image from black to white. A good histogram has no "right" shape, but should have a minimal gap on the right and taper off on the left.

✳ **Histogram skewed to the left**–sometimes you will have a histogram with a limited range of tones due to the light and other conditions of the scene. If the graph is mainly in the left side of the histogram, you run into the same problems with color and tonality mentioned above concerning underexposure. Keeping the graph in the middle of the range utilizes the part of the sensor that captures the best color and tonality. You can always make a scene darker in the computer, but making a dark exposure lighter always runs the risk of added noise, as well as color and tone problems.

✳ **Histogram skewed to the right**–some dark scenes will cause overexposure that will skew the histogram to the right. This may not clip the highlights, but it does present a problem with midtones. The colors and tones in the middle of the range of brightness captured by the sensor will be pushed up into the highlight area, which can cause problems with tonality and color. Color, especially, can lose its chrome or color quality and result in you having to do more work on the image to bring back the original colors.

Color

Good color appropriate to the subject or your creative vision for the scene is critical to the final print. The best color comes from capturing it correctly when the photograph is actually taken. In the exposure section above, you saw how exposure also affects color. Underexposure can cause problems with color in dark areas. Overexposure can result in challenges with colors in the midtone areas.

How you set white balance can also affect colors. Auto white balance in digital cameras works well, and if you shoot RAW, you can always change the effect later. However, I generally don't recommend using auto white balance when shooting in either JPEG or RAW. The problem comes from inconsistency and a weak interpretation of the colors in a scene.

Inconsistency comes from the auto white balance constantly setting a new white balance value for each exposure. If you shoot at a wide-angle focal length and then zoom to a telephoto, the camera will see different picture elements for its white balance calculation and will often use a different setting. Another example of auto white balance causing difficulties is when photographing single portraits of a group of people. If some have drastically different colors in their clothing, the camera will often change the white balance slightly for each.

This inconsistency causes real problems for printing when you are displaying prints from such a group of photos together. The wide-angle and telephoto shots will have different color renditions, and the portraits can change quite a bit in color, affecting skin tones.

TIP...

Learn to interpret your LCD. While the LCD is not perfect, and its view is affected by how bright the conditions are when you observe it, you can learn to "read" it for exposure problems. To develop this skill, you need to play with different exposures and see what they look like both on the LCD and on the computer screen. Using aids, such as highlight warning and histogram, can also help.

Correcting these differences and making consistent prints means a lot of work.

If a specific white balance setting is desired when shooting use manual white balance. This method takes a reading of the light in the scene and locks in the appropriate white balance setting. You can shoot at any focal length or a person with any color clothing and the colors in the scene will remain consistent in both JPEG and RAW. In JPEG images, this white balance setting is applied to the image and can be changed later in limited ways without quality issues (if the white balance is chosen correctly for the scene this limitation does not present a problem—use the LCD to confirm this). In RAW, the setting is also applied to the image, but can be easily changed with no quality issues.

JPEG or RAW?

RAW and JPEG images are both capable of the highest-quality prints. Some people will assert that you must use RAW for high-quality printing, but that is not true. There are advantages to shooting with each. Use what you need and what works best for you:

❋ JPEG–for fast work, quick editing, and quick prints

❋ RAW–for critical work, more processing flexibility and capability

RAW is great if you need it, but it definitely changes your workflow and it is not for everyone, pro or amateur. If you arbitrarily use RAW and it doesn't fit your needs, personality, or style, you may find you get less enjoyment from working digitally.

A JPEG file is not something totally unlike a RAW file; it is actually a camera-based RAW conversion. All

A good print is independent of RAW or JPEG formats. RAW offers more image processing options, but JPEG is faster and easier to manage.

cameras today have advanced algorithms to convert the 12-bit data from the sensor to the 8-bit data that can be held in a JPEG file. (The 12-bit sensor data is easily held in the 16-bit space of a RAW file.) It is like having your own RAW conversion expert built into the camera. However, the disadvantage is that you get one conversion, which may or may not be appropriate for your needs.

RAW does offer more flexibility in dealing with shots if you enjoy taking the time to work with it. It will help when the picture wasn't shot quite right (especially if exposure or white balance is off). It will avoid any potential problems of JPEG artifacts. And it offers potentially greater dynamic range with its great bit-depth of

color information (which can be very helpful in tricky lighting situations and when you need to make extensive adjustments to an image). RAW has the potential for the very highest quality, especially if you want to make very big prints that require a lot of enlargement from your image files.

I shoot RAW + JPEG simultaneously, therefore I get the advantages of both, but they require more memory. Many modern cameras allow this and memory cards are big and inexpensive enough to accommodate your needs. But my goal is to get photographers to have fun and really enjoy this terrific technology all the way through the printing process. It makes me sad to hear of people that don't enjoy processing in RAW, but feel guilty if they don't. It means someone has made photography less fun for them.

Should you shoot RAW or JPEG? Make that choice your own. Know that you can get top quality prints from both. Choose the format you use based on how you like to work, not from what someone else arbitrarily tells you to do.

A digital printing work-
flow is the process of
creating a print from
start to finish.

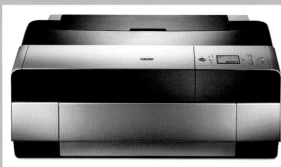

CHAPTER 4

Basic Printing Workflow

If you are ready to get started printing and don't want to read much more about things related to printing, then this chapter is for you. It is an overview of the core principles needed to get a good print in terms of workflow. The next chapter goes into detail on how to get the computer and printer to talk to each other and consistently create good prints. And the chapter after that covers how to best prepare an image for printing from Photoshop and other image processors. Those things are all very important, but you don't have to go through all of this information to get started. All you need to do is work simply, follow the ideas in this chapter, practice them, and you will be on your way to getting good prints.

The ideas presented in this chapter work well for most photographers. They come from my experience printing with a variety of Epson printers, as well as working with a lot of photographers in my classes and workshops. You will find different perspectives presented by different people who teach printing. You will also encounter specific information about printing based on a single photographer's limited experience with a certain printer or based on what was required for older printers. Printing is adaptable, and to a degree, a testament to the quality of engineering that goes into modern Epson photo printers. All of these different approaches and techniques will give good prints or people wouldn't use them.

Varying techniques work, but not for every photographer or every printer. My goal is to help you, as a photographer, get better prints. I want you to succeed. But it does not make sense for you to follow "my way" if it doesn't work for you. I will try to give you tips and techniques that can help you work out the best style of printing for you. I want you to understand the process of printing and how you can go from a good print, to a great print, to the best print possible, enabling you to have fun with this highly creative aspect of photography.

Workflow and Craft

Workflow has become a buzzword that gets bandied about as if it had some magic powers. If you learn workflow, or more precisely if you learn the "right" workflow, you will get better photographs.

Workflow is simply a term expressing the process used from the time you take a picture until the print is in your hand. Some of these steps, such as prepping your camera and setting exposure, will not be discussed here in great detail (although several things were covered in the last chapter). We will set forth an order for a workflow that will bring an image through the computer enabling you to get a good print.

Let me be straight with you. You get better photographs by taking lots of pictures and better prints by making lots of prints, not by following a workflow. Photography and digital printing are crafts. You can study them and learn about them, but to gain the experience of what works and what does not requires you to "do them".

I teach a lot of workshops, and a common question from many photographers is how they can streamline their workflow so they can spend less time in front of the computer. The answer is to spend more time in front of the computer! Before you throw this book at the wall in despair, allow me to explain. To master any craft, you need to work at that craft. Many years ago, young people used to become apprentices for master craftsmen. They would spend a lot of time working with that craftsman until

To make better prints, spend some time in front of the computer familiarizing yourself with the available tools. This is about mastering the craft of printing.

they learned the craft. At first, they did the work very slowly, but with practice and experience the apprentice became a craftsman, too.

Think about it. How did you learn to drive a car? I taught both my son and daughter how to drive. Now, both are very good drivers, but at first they struggled. I can remember having my daughter drive in an industrial park on the weekend when it wasn't busy. She'd swing out to the right in order to turn left! She was convinced she wasn't doing that, so one time as she turned left, I grabbed the steering wheel so she couldn't move the car to the right. She complained, of course, but she learned.

The point is that the learning process for many things requires us to make mistakes and see what happens, and photography and digital printing are no exception.

With experience, you start to intuitively know what needs to be done with a photograph. You become comfortable with the controls that affect a print and how to use them. You work faster and do better work. Eventually you are also able to learn and use efficient techniques to streamline your efforts.

But you have to do the work. There are no shortcuts I can give you that will get you processing images and printing them out quicker if you haven't spent the time with your images on the computer.

But don't think of it as computer time; consider it time spent with something you love—your photographs. I hope you love your pictures and subjects. Getting the most from them in a print can be a wonderful and satisfying experience, if you concentrate on the photographs, and not on the technology.

A Digital Workflow for Printing

A good print starts from the moment you press the shutter button. This continues through how you work with that image in photo processing software, such as Photoshop. It then depends on how the computer communicates to the printer and finishes with the actual printing. The physical printing of an image by the printer is a small part of that process.

As mentioned above, digital workflow is the process from the beginning to the end that defines how you work with an image. In this chapter, I am going to stick with image processing workflow (the "digital darkroom"), because it tends to

The print starts as soon as you press the shutter button.

create the most confusion.

It is not possible for me to give you all the techniques involved in each of these steps in a book on printing. There are many good books that go into more detail on many of these subjects. I will simply give an overview as it affects printing and will provide specifics related to Photoshop. Almost everything here also relates to Photoshop Elements, and most of these techniques are easily translated to any imaging software.

"Import" and "Save As"

When you open an image into Photoshop, save your opened photo as a new file. You can use either TIFF or PSD (Photoshop's native file). This will protect the original image (or the processed file if it came from a RAW converter). If you shoot JPEG, this also ensures that you do not use JPEG as a working file, which should be avoided. There are times when you will need to go back to this original file when a processed image is not quite working right as a print.

The next steps in the workflow can be done in either a RAW converter (with RAW files) or in the image processing software itself (for JPEG files). These are overall adjustments that will affect the entire image.

Crop and Rotate

I am a strong believer in cropping out problems early. This is to remove distracting elements from the image, not crop the image to a specific print size—that should come later in the process to allow for flexibility in print size. It is important to remove the junk that shows up along the edges of an image and fix crooked horizons early in the process. This frees you creatively because you aren't distracted by stuff that doesn't really belong in your photo. In addition, unwanted stuff along the edges can wrongly influence adjustments of the overall image.

When you begin working on a photo, be sure to save an original version of your image and make your adjustments on a working copy.

The Blacks threshold screen as blacks in the image are set.

The White threshold screen as whites in the image are set.

The Curve tool used for adjusting the midtones.

Adjusting Black and White Image Areas

This is one of the most important early steps you can take—it can have a huge effect on a print. Color and contrast of the final image starts right here. Many photographers try to deal with color first by using a saturation control, which can cause problems when printing.

Photos not properly adjusted for these tones will have weaker contrast and less-than-optimum color. Most cameras do not record the solid black you need for a good print in the darkest part of your image. One of the reasons cameras do this is because it can help capture more detail in the shadow areas. Technically, there is only a black or a white tone. However, there are many black and white areas throughout a photo, which is why blacks and whites are commonly referred to as plurals.

Levels is an ideal tool for making adjustments to the blacks and whites. In Photoshop and Photoshop Elements (plus Adobe Camera Raw and Lightroom using Shadows/Blacks and Exposure), hold down the Alt (Win) or Option (Mac) key as you adjust the black and white sliders. This reveals a threshold screen that shows you where blacks and whites appear in your image.

One scene might need the blacks and whites just barely appearing (or maxed out channels), yet another might look better with large areas of black. I am usually less aggressive in adjusting for whites—this can quickly make bright areas look washed out.

Clarify Midtones

Midtones give a scene a feeling of luminosity and can make an image come alive. Dark midtones can look muddy and make colors less dynamic. Overexposed midtones make colors look washed out. A good way to deal with midtones is by using Curves (or the Tone Curve in Camera Raw and Lightroom). Click and drag from any part of the line and the picture changes—brighter as the line goes up, darker as it goes down.

Color Correction

A wrong white balance value or a scene with an overall color cast can be easily fixed with Levels (this needs to be done as a separate step from adjusting the blacks and whites). Pick the middle eyedropper (while called the Gray Point eyedropper in Photoshop, it works exactly the same as the white balance eyedropper in Camera Raw and Lightroom) and start clicking around the image, looking for things that should be neutral in tone (such as a cloud, the ground, a white flower, etc.). You will usually get a good-looking image fairly quickly. You can also tone down a strong change by using an adjustment layer and changing its opacity (this is a valuable technique to know).

Color Adjustment

This is where you can adjust the saturation of an image. I recommend using the saturation slider of Hue/Saturation rather cautiously. If used too aggressively, it will cause colors to block up, hiding detail, and it will quickly make colors look garish. All colors do not record equally, so many photographers will push saturation up in order to make a certain color stronger. The problem with this type of adjustment is that then other colors look bad. I would recommend you keep Saturation adjustments to 10 – 15 points or lower.

The best way to handle color saturation changes is to use the individual color adjustments available in the Hue/Saturation controls. If you click on the Master section in Photoshop's Hue/Saturation, you will see a group of colors. (Individual colors are also available in Lightroom and Camera Raw.) Choose a color, then adjust it for optimum appearance. This allows you to increase

Color correction should happen after the blacks, whites, and midtones are set.

The Levels screen as color is corrected with the middle gray eyedropper.

The Hue/Saturation screen as color is enhanced and adjusted.

certain colors quite a lot without hurting the overall look of the photo.

Make a Work Print

As discussed earlier in the book, a print is a very different animal from an image on a monitor. You must judge what a print needs by looking at the print as its own entity, rather than simply comparing it to the monitor. I really part company with some of the more computer-oriented folks on this subject. They believe all you need to do is soft proofing on the computer and that prints are not necessary. I do not believe it is possible to get the best possible image without making a work print to evaluate.

I think it is unfortunate, too, that the Internet breeds a

certain cynicism that is not always based on real-world experience. There is this idea out there that any encouragement of making more prints is just a sellout to Epson so they can make more money. This is nonsense and a disservice to photographers who really want to go beyond a good print to a magnificent print. The historically great printers, such as Ansel Adams and W. Eugene Smith, would sometimes make hundreds of prints until they got one they liked, refining each print one step at a time. You don't need to make multitudes of prints because you can evaluate an image on the monitor, but you can't use the monitor as your ultimate judge of a photo without at least some work prints. After looking at your prints, you will be able to refine your earlier adjustments to make an even better print.

Make Local Adjustments

Local adjustments are small area changes in a photo that do not affect the entire image—you

The Layer palette is an important tool for image adjustment. Layers allow better control with each adjustment, especially if you incorporate layer masks into your workflow.

TIP... Layers are a very important part of Photoshop and many other image processing programs. You can use adjustment layers for any of the earlier steps. These don't alter any actual pixels until you choose to apply them, so you gain a lot of flexibility in making changes when you use them.

might want to lighten a face without changing anything else. You may need to open up a dark corner of a room without making bright areas brighter. You might want to correct the color of a flower without changing the color of the sky. For most prints, you may find that parts of your image need to be adjusted separately from the rest. The best way to do this is with adjustment layers and layer masks. I highly recommend you take the effort to learn how to use these very useful tools.

Cleanup

The previous adjustments have brought the photo to a point where it looks pretty good. Now you can fix problems in the image, such as flare, noise, or other unwanted elements. If you make these changes earlier in the process, the latter adjustments can cause problems. Use the Clone tool and Spot Healing brush to remove annoying problems. (The key to the Clone tool is to use it in steps, change the "clone from" point as you go, and vary the brush size—make sure to practice!). For noise, try software specifically designed to remove it, such as Nik Software Dfine.

Save a Master

Save your unsharpened and layered image as its own, separate file. Use this file to make adjustments for printing specific sizes—you can have problems changing image size on a previously sharpened file. Plus, having the layers available for tweaking keeps the final image at its optimum quality (compared to readjusting a flattened file).

Sizing the Image

For best results, the size of your image needs to be adjusted in the computer to match the needs of your printer. There are many misconceptions regarding the relationship between the megapixels and the print size of an image. Megapixels determine how large you can print an image, but by themselves do not equate to quality in a print. It is only when they match the printer's needs that quality is achieved. A printer needs a certain resolution in pixels for a given print size. More pixels add nothing, and can even reduce the quality of a print (the printer discards excess pixels and can do this in such a way that the sharpness of the image is compromised). Not having enough pixels will also result in lower image quality.

There are many ideas about what is the "right" resolution for printing. Most of these ideas work, though they sometimes cause unintended problems for the photographer. Many of the very conservative ideas and numbers, such as you must print at 360 ppi, are based on the specifications of old printers that were common

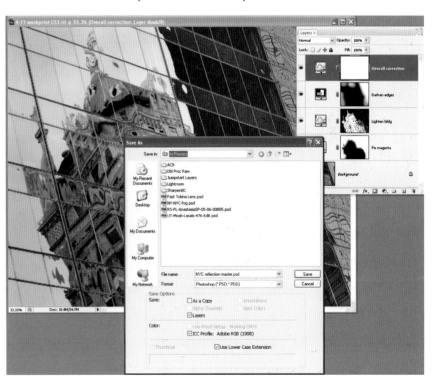

Save the layered image as a master image (the .psd file format in Photoshop) that you can go back to and readjust as needed.

When sizing a photo, first check its size at 360 ppi (for a smaller photo) and 200 ppi (for a larger photo) before you check the "Resample Image" box. Use "Resample Image" only if you need to go beyond these sizes.

ten years ago. These measures are not needed for today's Epson printers.

An image needs to have an adequate printing resolution and be sized for the desired print. Printing resolution is a pixel resolution that the printer recognizes, and from which it can make a quality print. Printing resolution for most printers today—Epson and others—is anywhere from 200 to 360 ppi. (Some folks will give this range as 180 – 360 ppi—do your own tests to see what you get at 180 ppi).

No matter what anyone says about "must have" resolution, the numbers quoted above will work. I've heard some "numbers freaks" argue that you can see the difference between a 360 ppi print and a 280 ppi print "if you use a magnifier." When was the last time you were handed a magnifier at an exhibition of photography? If the only way to tell if a print is good is by examining it with a magnifier, rather than how the image affects the viewer, the art of photography has lost a lot of its value.

To properly size an image, it is best to start with the original pixels. Turn off any resampling commands so the image file size does not change. Plug in 200 ppi to see the maximum size the image will print with its native pixels and 360 ppi to see how small it will be. For any sizes within that range, type in a width or height and let the ppi automatically adjust to your specifications. This technique will not provide you with a specific height and width—say 8 x 10 inches (20.3 x 25.4 cm)—unless the original pixels match those dimensions. To get a specific print size, you need to adjust one dimension (height or width) to fit the desired size with the other dimension ending up larger than needed. Then, go back to Photoshop (or another program) and crop to the desired size.

To make an image larger or smaller than the sizes determined by its natural range, you need to resample or interpolate the photo. To make an image larger, set the resolution to 200 ppi, select Resample in Photoshop, and type in the image size you need. You will notice the file size will increase. Then select Bicubic Smoother for Adobe products—designed to make higher quality enlargements. To make a photo smaller, set the resolution to 360 ppi, select Resample, and type in the image size you need. (200 and 360 ppi allow you to minimize interpolation for larger and smaller images, respectively.) But this time, instead of selecting Bicubic Smoother, select Bicubic Sharper for Adobe products—designed to maintain sharp detail as pixels are removed to make an image smaller.

If you need to enlarge an image quite a lot from the original file size, you really need the photo to begin with the best quality image file. Any problems with tonalities, noise, or color will only get worse as the print gets bigger. Many photographers find they get the best results when enlarging an image if they enlarge from a RAW file during the RAW conversion, rather than later in Photoshop (or another program). There are also programs like On One Genuine Fractals and Alien Skin Blow-Up, which are designed for high-quality interpolation of image files. I have found they don't offer much of a change in image quality when increasing file size by small amounts, but they can help when making big changes (such as making a poster-sized print from an 8-megapixel camera).

Image sharpening can be done a number of ways, however it cannot make a soft image sharper. Sharpening is designed to bring out the inherent contrast between light and dark pixels and doesn't add image information.

Sharpening

A photo should be sharpened based on its printed size. The size of the image has a big effect on what details show up in a photo and how it should be sharpened. Therefore, a photo should be sized before sharpening. In addition, there are good reasons for sharpening a photo late in the image processing workflow. Many adjustments to an image can affect detail rendition and noise, both of which affect sharpness. Thus, sharpening too early can result in less than optimum sharpening for a subject, plus it can result in sharpening artifacts that are later intensified from further work on the image.

Sharpening is very subjective, but it is important to realize that sharpening is not about making a blurred image clear, it is about getting the optimum sharpness from a photo that is already in crisp focus. An image direct from a sensor or a scanner is not at its optimum sharpness. This is caused by a number of reasons related to the technologies involved and results in the image needing to be sharpened in order for it to look as good as a print as it did when the lens created the image on the sensor or film.

There are many formulas and ideas for sharpening and, frankly, they all work. But all sharpening techniques will not necessarily work well for every

> **✳ TIP...** If you still have doubts, create a test with several prints from the same image printed at multiple resolutions. I have done this and given the prints to very sophisticated photographers to pick out the best one and place the prints in order of quality. No one has been able to pick out a "best one" or place them in order, though they certainly have tried.

photographer or subject. A sharpening technique perfect for an architectural photographer can be dead wrong for a portrait photographer. A sharpening formula that works well for a rocky landscape may be inappropriate for a soft flower image.

Unsharp Mask is the basic sharpening tool. Smart Sharpen and various plugins can also be used in Photoshop, and will be discussed shortly. But, Unsharp Mask (or USM as it is often called) is the sharpening tool of choice because of its control.

USM has three basic controls: Amount, Radius, and Threshold. They work together; if you have seen many formulas for USM, you will notice that as one changes, the others change (especially Amount and Radius). For example, any number for Amount is meaningless without knowing a Radius. Here are some ideas on how to set them:

✳ Amount–this control is the intensity of the sharpening. It needs to be higher when detail is fine, radius is low, and/or any time you need more sharpness from a subject (again, you can't get sharpness from a blurred photo and increasing amount will only decrease the quality of such photos). You will generally use higher settings for highly detailed subjects such as architecture and landscapes, and lower settings for gentle subjects such as people. I like an amount of 100 – 180 depending on the subject and based on the radius I like to use.

✳ Radius–this is where the sharpening actually occurs. Sharpening affects the details where there is contrast along an edge (this is what sharpness is based on). It is based on a limited numbers of pixels because most sharpening occurs at the individual pixel level.

Radius tells the program how far to look for this contrast from pixel to pixel and is strongly influenced by the size of the photo. A large photo has more pixels, so theoretically, you need slightly more radius across more pixels to achieve the same effect as you would on a smaller photo.

I generally use a radius between 1 and 1.5 for most images, going up to 2 for a very large print (with a file size of more than 30MB) and going down to less than 1 for very small prints (with a file size of 6MB or less) and subjects that don't need a lot of sharpening. I vary the amount of radius depending on the subject. My numbers represent a more aggressive use of radius than some photographers like. The danger of my technique is unsightly halos of brightness around strongly contrasted edges, but the benefit is crisper tiny highlights, which give the image a stronger feeling of brilliance and snap. I will watch the 100% image preview to be sure I am not creating halo problems, but, unlike some photographers, I do not enlarge the main image to 100%. This enables me to see the overall effect on the image, including image brilliance (which is harder to interpret at 100%).

✳ Threshold—this control affects where the sharpening will occur based on the contrast of an edge. A low threshold gives high sharpness, but it also sharpens noise and other artifacts. A high threshold reduces the sharpness in small details.

For most digital cameras, I will use a threshold of 3 – 4. If I find any noise problems, I increase this up to 10 – 12, but never higher. I look for the grain in scanned images to determine the threshold for film.

Smart Sharpen in Photoshop is a newer algorithm designed for sharpening. It works similarly to USM but with better compensation for halos and other artifacts. When it can be used, it gives very good results, but the drawback is that it has no Threshold setting. This means that Smart Sharpen often increases the appearance of noise in a photo, and for that reason, I use it on a limited basis.

I also like Nik Software Sharpener Pro for printing. This program does some nicely automated sharpening for specific printer types, print sizes and viewing distances. It also uses some advanced sharpening algorithms, which give excellent sharpening results (including boosting image brilliance). But the biggest benefit of this program comes from the Advanced settings. There you adjust how much it will sharpen areas based on their colors and tones. This allows you, for example, to not sharpen a color or tone that reveals a lot of noise (very often noise is most common in specific colors or tones).

At this point, your photo is ready for printing. Of course, you need to look carefully at any print to be sure the photo is working as a print. Sometimes one print will give you exactly what you want. But if you keep the concept of "work print" in mind, you will look at the first print differently. You can then evaluate the print to see what can be done to make it into an even better print, if possible.

In the next chapter, we'll look at setting up Photoshop and other programs for printing, and how to set the printer driver.

JOHN PAUL CAPONIGRO

CRAFTING A DISTINGUISHED STYLE

John Paul Caponigro is a member of the Photoshop Hall of Fame, an author, a contributing editor to Digital Photo Pro and Camera Arts, a columnist for Photoshop User and After Capture, and contributor to apple.com. His artwork can be found at Princeton University, Estee-Lauder, and the Smithsonian. Having taught workshops for over 12 years around the country, he has spent a lot of time with digital photography and ink jet printing. According to him, ink jet printing, from one point of view, has not changed photography much, since one can still achieve most of the traditional photography objectives and aesthetics through digital technology.

On the other hand, he feels ink jet printing has changed photography entirely. He no longer has to be in a darkroom to make prints.

There are no wet or toxic chemicals. He has more of an advantage since the tools he now uses for printing are ready at a moments notice and produce consistent prints. They also bring out the richness of colors that may not have been visible prior to ink jet printing. Technology constantly pushes Caponigro to reconsider previous assumptions, and it keeps him on a continual learning curve.

Caponigro sells limited edition fine-art prints straight from one of his Epson Stylus Pro printers, the 3880, 4880, 7880, or 9880. He has used Epson printers since the early 1990s to make posters, notecards, handmade books, promotional materials, and family portraits. Because of all the different projects he prints for, his prints greatly vary in size—anywhere from 5 x 7 inches (12.7 x 17.8 cm) up to 30 x 40 inches (76.2 x 101.6 cm). Caponigro prefers to use UltraSmooth paper for his fine-art prints because "the surface is sensual, yet capable of holding fine detail and subtle gradation."

The best thing about ink jet printing, according to Caponigro, is that it offers so much versatility and control. He recognizes the fact that there is always room for improvement and he thinks that an area printer manufacturers need to focus on is durability. "Ink jet prints can achieve substantial longevity, but fragile surfaces can be compromised if they are not handled with considerable care," he says.

"Spend time to clarify your unique point of view in order to craft a distinguishing style," Caponigro advises photographers.

He also suggests that one explore the many options available. "Make a wide survey of available ink jet printing materials—especially substrates. Each one will provide significant differences. Some of those will enhance the expression of your work better than others."

He encourages photographers to not feel like they are doing something wrong if they make a print to physically proof images—this is the road to getting the best print.

Caponigro's website is at www.johnpaulcaponigro.com.

A great print requires
good communication
between the image
processing software and
the printer.

Printing from Image Processing Software

To get a good print, the computer and printer need to communicate and understand one another. Printing is just like any type of relationship—when partners don't talk to each other, problems can occur.

Most photographers print from image processing software such as Adobe Photoshop, Photoshop Elements, or Photoshop Lightroom—these programs also have to communicate with the printer. Most of the controls and adjustments in these programs will also apply, or can be easily adapted, to other programs such as Corel Paint Shop Pro.

This chapter will provide an overall workflow for printing from a program like Photoshop. We'll go into more detail on what it means to prep an image for printing and to get the most from using a work print in the next chapter. Some readers will be able to skim this chapter and spend more time on the details in the next. Others will want to develop a greater understanding of this part of the workflow before getting into specific image-processing details.

Printer vs. Program Control

While the program used and the printer itself are important to a print, one of them ultimately has to be the arbiter of how colors will be interpreted on the printed page. Excellent results can be achieved using either method, but you must choose one way or the other.

You will hear from many top photography pros that having the program control the printing, along with choosing paper profiles, is the best way to go. This is true, though with a caveat. Since most pros only work with pro printers and have never printed with the full line of Epson printers, they usually have no experience beyond the printer they are using. Using a color profile for a specific paper will give increased color gamut (range), better color accuracy, and better color gradations when using these printers. However, the less expensive, non-pro printers will give excellent results without paper profiles when you allow the printer to control the printing.

As noted in the last chapter, it is great benefit for Epson to create algorithms that the printer uses to control the printing process, especially with less expensive photo printers used by casual photographers. If the printer controls the printing process (actually, it is the printer software), then that is something Epson can control. If

When working in Adobe imaging software, you have the option to let the software or the print driver control how the color is rendered (or how the colors are translated from pixels to inks).

the engineers can create printers that do this with less effort from the photographer, they are increasing the chances that most people will get better prints.

Most pros still use the program control route for printing. The reason for this is that they can have better and more precise control over the results. When the printer controls the printing, you are allowing a lot of

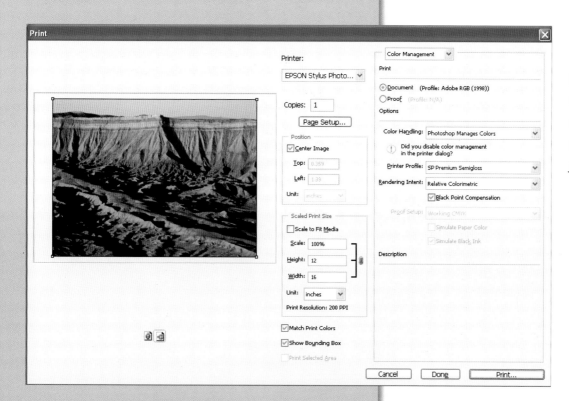

Photoshop CS3 makes the printing choices easier than before and in a more user-friendly format.

automation based on engineering decisions to affect your print. This is very good automation, to be sure, but it is still out of your control. When you use a program like Photoshop to control the printing, you gain the advantageous ability to set certain parameters, such as paper profiles, exactly as you want. The downside is that these controls are more precise and if they are wrong, they can be very wrong. This chapter is about printing from a program, therefore we will emphasize that route.

Program Control

Most imaging programs allow you to control how a photo will be printed. This includes the use of paper profiles and other settings. A paper profile is a very specific set of instructions about how colors and tones translate from the computer to the printer for printing on a specific paper with a specific printer.

When the program is controlling the printing, it sets up colors and tonalities (such as how blacks are rendered) based on how a certain paper deals with the ink coming from the printer. Papers have biases on how colors and blacks are absorbed and, therefore, reproduced in a photograph. The computer must be able to recognize

these biases so it can compensate for them with the paper being used.

NOTE: If the program is controlling the printing, you must go into the printer driver and turn off any color management settings. If both the program and the printer are trying to control, or manage, the printing (which is what would happen if color management were left on), you will get conflicts that make it difficult to get a good print. This will be discussed in greater detail later in the chapter.

Page Setup and Print Size

The first step in the printing workflow is to direct your program to send your image to the printer at the appropriate size. The page setup controls in the program allow you to select which printer to use if you are using more than one printer, as well as choose the size of the paper and its orientation (vertical/portrait or horizontal/landscape). Many programs allow you to set this up before going to print, but I find this to be a waste of time. I prefer to make these adjustments when I make the print itself, using the print dialog box of the program to do this.

This is especially true with Photoshop CS3. Adobe has made their new print dialog box much easier to use by putting more controls in the box, rather than needing to go to the Page Setup control to choose printer and orientation. This can be a little confusing since there still is a Page Setup control in Photoshop CS3, but it is not used in the same way as with older versions of Photoshop.

NOTE: I will use Photoshop to demonstrate this process, but you will find these controls in any image processing program.

The paper size control is accessed through the Page Setup button (orientation and printer choice may also be found here). Photoshop CS3 will give you a preview showing the placement of the photo on the page. The preview is now a small "soft proof" or visual representation of what the print will look like on paper. Access paper size through the Page Setup button (also where you find orientation and printer choice). If you check the preview in the Print dialog box when you open it, you can see if the image is correct for the paper, if it is aligned properly, or if the paper is the correct size.

While you can "resize" the image at this point using Scaled Print Size, I only recommend this if your photo will not change in size too much. If you simply go from 8 x 12 inches (20.3 x 30.4 cm) to 7 x 10.5 inches (17.7 x 26.6 cm), you will not encounter too many problems. But a change from 8 x 12 inches (20.3 x 30.4 cm) to 11 x 16.5 inches (27.9 x 41.9 cm) will cause difficulties. If you want to achieve optimum print quality, you will need to deal with sizing the image yourself, not allowing it to be done automatically.

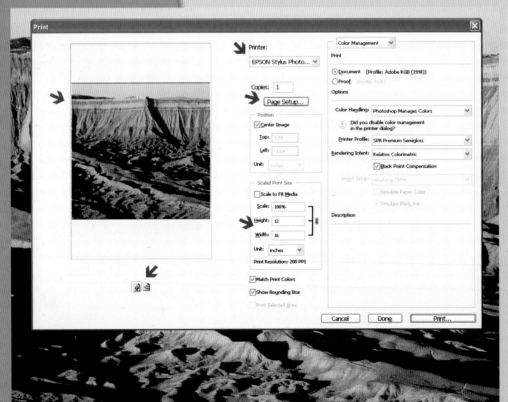

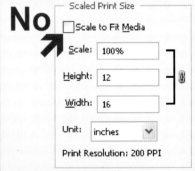

These areas affect the size and the position of the image in the Photoshop print dialog. If you need to completely resize an image, do it in Photoshop, not in this dialog.

When you want to make several different sized prints of an image, size and sharpen your photo properly in Photoshop for each size first. An image looks its best as a print when it is sized and sharpened for specific print dimensions. This means you need to use the correct sizing tools (such as Bicubic Smoother or Bicubic Sharper) on an unsharpened image and sharpen it with settings chosen purposely for the new size.

As you set up the page for printing, Photoshop will allow you to choose the placement of the image on the page through the Position choices.

✳ TIP... Always save your sized and sharpened images as separate, new files. I recommend that you flatten any layered files and keep these as simple, complete files ready for printing. They can be TIFF or high-quality JPEG files. At this point, there is no reason why you cannot save this file as a JPEG file with low compression in order to save space on the hard drive. Since you will only be printing from this file and doing no adjustments (adjustments should be done to the unsharpened master file, saved as a PSD file), there is no quality issue from using the JPEG format. I like to save these files with the size in the file name (e.g., AdamPortrait12x18.jpg); this tells me I have sized and sharpened the photo.

Entire books have been written on color management. They can be helpful for people who need that information, or for the highly technical enthusiast who wants more background information, but most amateur photographers don't need such detailed information to make a great print. I have found that sometimes an overemphasis on the technical aspects of color management intimidates a lot of photographers and keeps them from really getting their best results.

Still, knowing a bit about color management is helpful. There are places that go into more detail about it, but here is a quick summary:

Color management refers to the way color is consistently interpreted through the entire process, from when a photo is shot (digital) or scanned (film) to the physical print (or other use).

A color space defines the range of colors that the computer will interpret in a given photo and how that range will be handled. You might consider color spaces the equivalent of when photographers had film choices, and each reproduced color slightly differently.

Adobe RGB (1998) and sRGB are the two most commonly used photographic color spaces. Both work well—Adobe RGB gives a greater range of color and more possibilities in adjustment when compared to sRGB.

Some photographers are starting to use Pro Photo RGB for their color space because it works with Epson Ultrachrome K3 inks better than either Adobe RGB or sRGB.

You can decide to work within any of these spaces and optimize your prints for a particular space, or you can choose one that best meets your color print needs. You should figure out which works best for you; don't go by what someone else says you "should" do.

Photoshop and other programs work with color based on the color space that has been selected.

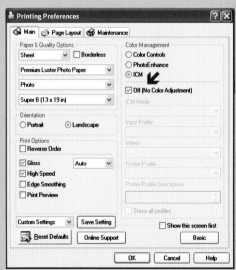

If you choose Photoshop to manage the image colors, you must tell the printer not to. The top image shows this on a Mac, and the bottom image shows this for Windows.

Monitor calibration makes colors display consistently and predictably on the screen so that the monitor's interpretation of the colors is directly related to the way Photoshop deals with the color space.

Paper profiles are created to interpret and manage color as it is printed to a paper from a color space. These profiles are specific to a paper and printer combination. If the ink or paper is changed, the profile has to be changed to match.

CAUTION! I know I have said this before, but it's worth repeating here—when you choose to have Photoshop manage colors and you select a profile, you must turn off any color management in the printer driver.

You can move it left or right or up or down on the page for precise placement. These adjustments will be displayed in the preview. This type of attention to image placement can help you create a print that can be mounted and displayed immediately, without needing any special mounting work.

Occasionally, photographers will run into conflicts with a printer—it does not place the image properly. You may have to set both the printer driver and program settings for placement, or even try different combinations. If you still encounter problems, you may have to contact tech support.

The color management control in the Print Dialog box furthers the color management you began when you started working with your image and first chose a color space. This could have begun as early as when you initially took the picture, if you selected a color space in your camera.

But you are not choosing a color space here—that is imbedded in the image file. This is where you tell the computer how to interpret that color space for the printer by choosing a paper profile. This is important because the printer and computer must be communicating about color in a way that they both understand. It is like living in a multilingual community where two people need to speak the same language to communicate accurately to each other. The printer has no idea what the data coming from Photoshop means unless it is packaged in a specific way.

Paper Profiles

Every paper deals with the inks from a printer differently. If you were to print on several papers with the exact same settings in the program and the printer, the prints would look different. One paper might favor certain colors, another specific tonalities. I can remember using ink jet printers with different photo papers in the early days of printing. You could often see a visible difference

in specific color response among the prints—we didn't have the profiling capabilities we have today.

A printing profile is a set of instructions the computer uses to interpret a file for printing on a specific paper. This profile is created by making a print from a standard color test file, measuring how those colors appear on the paper used, then creating instructions for the computer on how to modify that file so the colors reproduce more accurately.

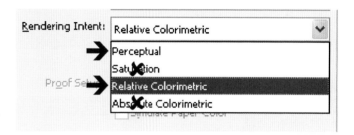

Usually, photographers choose "Perceptual" or "Relative Colorimetric" for Rendering Intent. There is a slight difference between them, but most photographers will find that "Relative Colorimetric" works well.

Luckily, Epson has done this for you for all of its papers. You could spend a lot of time or money making unique profiles, but I can tell you from experience, it is rarely worth it for Epson papers. Epson wants photographers to have good results, so of course it puts a lot of effort into its profiles. Many profiles come with the printer and are installed to the computer when you install the printer software (printer driver).

If you are using independent brands for papers, you won't automatically have these profiles. You can usually get them from the manufacturer, but I have to tell you a secret— you can do some quick tests and use one of the Epson paper profiles to print on an independent paper. Just use one with a similar name; for example, an independent luster will probably be similar to an Epson luster or semi-gloss. If that does not work, however, you will need to get a profile.

Using a profile is very simple. You will find a choice for profiles under the color management area in the Print dialog box. Click on the drop-down menu and you will get a whole list of profiles. Look for a name that matches your printer and the type of paper. You may see some modifiers such as MK (matte black) or PK (photo black) for the black inks used in some printers.

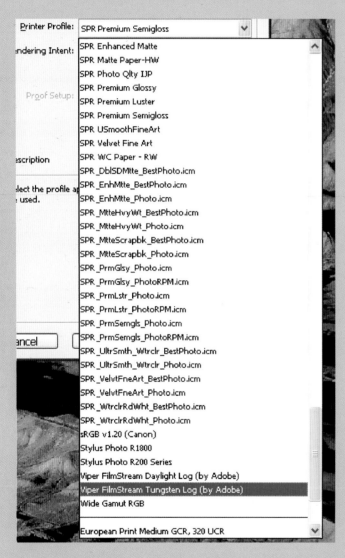

When Photoshop manages color, you must select the color profile appropriate to the printer and the paper you are using.

Once you choose a profile, you will also see Rendering Intent, and sometimes, Black Point Compensation. You always want the black point option checked for the best blacks in a print. There are two options that matter for photographers in the Rendering Intent drop-down menu: Relative Colorimetric and Perceptual (ignore the others). These options provide additional instructions to the computer on how to modify colors for printing. Most photographers could leave this on Relative Colorimetric and have consistently great prints, but there is a difference between these two settings. You could do some tests to decide which you like better for most photos (though this will change from picture to picture). You can check out the differences between these with soft proofing, but to me, it is never worth the effort. I like sticking with one (relative colorimetric) and getting to know it well so I can interpret my photos automatically with its color rendering intuitively in my head.

Some people obsess over profiles. They constantly create new ones, searching endlessly for the perfect profile. Honestly, the only differences you see in the profiles they create are tiny nuances, and I have yet to see one that looks decidedly better than the manufacturers' profiles.

On the other hand, there are some reasons for doing your own profiling. For example, various print profiling hardware and software allow for some interesting tweaking of profiles that can create some unique-looking prints. This can be especially valuable for fine-art, black-and-white printing.

Soft Proofing

Photoshop has a control called Soft Proofing that many pros like to use (Match Print Colors in the CS3 Print dialog box performs a similar function). Using this control is especially popular with a lot of heavy-duty computer folks. This sets up your screen to mimic what

a print would look like on a certain paper based on your paper printing profile. It does work, but I think it can be misleading if you spend too much time looking at it rather than actual prints. I will tell you why and you can make your own decision. You will need to check any number of Photoshop books to learn how to best use it; I am not going to be the best source since I am not fond of it.

My basic problem with soft proofing is not that it doesn't work, but that it can be misleading. I believe it puts too many photographers on the wrong path. It gives the idea—which you have seen in the previous chapter that I don't agree with—that it is a good thing to believe that matching the monitor will lead to a good print. I strongly feel that you must evaluate a print for its what it looks like as a work print, and that trying to evaluate a "print" for what it looks like on the screen is a serious distraction from the craft of printing. I really think that to make a great print, you must make prints and evaluate prints, not an interpretation of a print on the monitor.

Printer Control

If you decide to tell Photoshop to allow the printer to manage colors, the printer driver handles all of the color management we have discussed thus far. The simplicity of this technique may seem like a good reason to print this way and, truthfully, many photographers have found this an easier method for getting excellent prints. The disadvantage is that you lose some control—this is an automated way of printing that does not fit everyone's needs. And with certain printer/paper combinations, there is no question that the profile route will provide superior results.

Still, it may be worth doing some experimenting. Try the option that allows the printer to take control over the colors—look for something that says "printer color management" or "allow printer to manage colors."

(Adobe has not kept the wording for this choice consistent and other products use other names.) Then in the printer driver, make sure that the color management choice is selected.

When you choose to allow color management to be controlled by the printer, you do still get some additional controls in the printer driver (described further in the next section). The most basic is in the Epson Vivid or Epson Standard color controls. The Vivid will make a livelier print, but you have to be careful or you can make an image too garish.

Many Epson printers also have something called PhotoEnhance. This automatically applies adjustments to an image similar to those you control when using Photoshop. Since you are reading this book on printing, I am guessing that you will want to control these

For many lower-priced printers, the "Printer Manages Color" option works very well. If you find you are having trouble with Photoshop's color management, experiment with this setting. Make sure to leave "No Color Adjustment" or "No color management" unselected.

adjustments, so I would not recommend Photo Enhance. The only time it can be advantageous is if you need a quick print for a friend or relative and are printing the photo directly after downloading it to the computer. This only really works with JPEG files. You simply open the image in your image-processing program and directly print it, allowing the printer to control colors and using a PhotoEnhance setting appropriate to the subject. This allows you to get a quick and easy print.

The Printer Driver

The printer driver is the printer software that "drives" the printer to create a print. It is a very important piece of the printing workflow. There are some key parts of it that you need to set. I will go over these in a generic way because this is one place where Mac and Windows (PC) platforms are quite different. The same choices are present, but are organized with totally different design philosophies.

For Windows, the printer driver appears with a unique interface designed by the printer company. All the choices are generally kept pretty simple, though you may have to go through a couple of tabs to find everything you need. This interface is accessed through the Windows Print dialog box, found by clicking on Properties.

For Mac, the printer driver is buried inside the Mac printer interface. Surprisingly for Mac, it is much less visual than Windows and has a lot of tabs. Still, as long as you know what you are looking for, both interfaces have the right stuff.

There are a number of key things that must be set in the print dialog boxes and the printer driver. The following tells you what to look for:

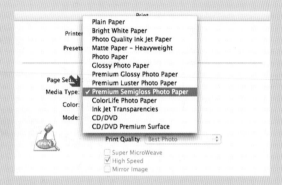

Whether it's Photoshop or the printer managing color, you must select the appropriate paper for the printer. This tells the printer how to apply ink to the paper.

✳ Number of copies

✳ Print orientation–horizontal or vertical

✳ Print quality–you have to tell the printer that you are making a photo print, so that it sets printer resolution appropriately. It does not know this from the information it is getting from the computer.

✳ Paper choice–you also have to tell the printer what paper you are using. Even though you chose a paper

printer profile, the printer is only using that information to adjust colors, not to determine how to put ink down on the paper. Telling it the kind of paper you are using gives the printer some very specific instructions on how to lay down ink.

✳ Color management–if you are printing from a profile find the place where it says no color management and select it. If you are letting the printer manage colors, use the default color management.

✳ Borderless printing–you need to tell the printer if you want a print without borders.

✳ High-speed printing–these are settings that influence how fast a print can be made. These used to cause problems with certain subjects, especially broad areas of tone or color, such as the sky, so photographers would turn them off. I have done a lot of testing with the most recent printers and have found they rarely cause a problem now. If this is a concern of yours, it is a simple matter to make a print with and without these settings.

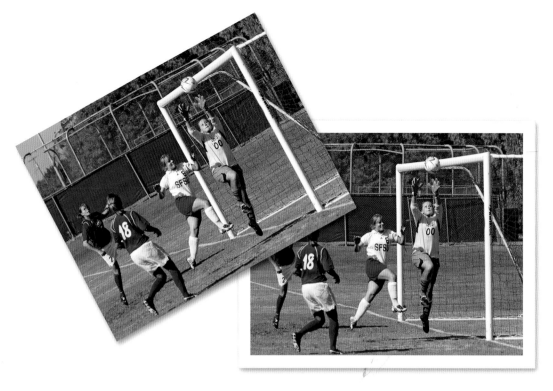

(10.2 x 15.2 cm) prints continuously on the roll paper. Some printers even include an automatic cutting feature.

Borderless printing is fairly simple as long as you have the right paper. You will simply need to select the borderless option in the printer driver. With roll paper printing, you need to be sure Roll Paper is chosen and not Sheet Feeder.

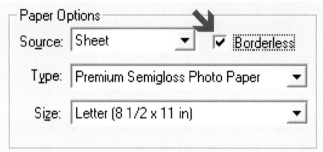

Most Epson printers print borderless photos, but you must command the printer to do so, and you must be certain your image is big enough to fill the page.

Borderless Prints

Borderless prints from the local minilab have become the format of choice for most people. You can duplicate this look quite easily with most Epson printers. They enable you to print edge-to-edge, borderless images without needing to trim the paper. This is not possible with all papers; your manual (and the Epson website) will tell you which papers support borderless printing. Be careful when using thin papers for borderless prints—the ink can over-saturate the edges.

One really great way to go borderless is by using an Epson printer with roll paper capabilities. You can set up a whole series of photos by queuing up print after print in any program, and then printing 4 x 6 inch

Printer Resolution

Epson printers automatically select an optimum printer resolution when you select the print quality. However, some photographers like to choose the resolution themselves—try this if you'd like, but you will probably find it hard to surpass Epson's optimum settings.

It is important to understand that printer resolution is not the same thing as image resolution. Image resolution refers to the pixels in your photograph, whereas, printer resolution refers to how the ink is laid down on the paper. These are two entirely different things. Some people have made a case that they are related, but with modern Epson printers, they are not. This is because, no matter what pixel resolution you set, ink droplets are laid down at variable resolutions (up to the maximum). The algorithms that control this are amazingly complex.

Epson prints at three photo settings: 720 dpi, 1440 dpi, and 2880 dpi. Some Epson printers let you choose these numbers; others do not. Typically, however, the Photo option selects 720 dpi, Best Photo selects 1440 dpi, and Photo RPM gives 2880 dpi.

You may have discovered that your printer has a higher number than these. And you may have heard that this super-high resolution gives the best photo prints. To be blunt, it doesn't.

In the printer resolution marketing battle, manufacturers have tried to match every high resolution that any other manufacturer throws out. True, the very high resolutions such as 4800 dpi or 5760 dpi are printer resolutions, but they also are numbers that have little or nothing to do with photo quality. Some photographers insist that they give better "gallery quality" prints, but I am skeptical. I certainly have not seen evidence of that.

While these high resolutions do sell printers, they slow down printing (a lot) and use a little more ink.

As already mentioned, Epson printers are optimized for photo quality printing at 720, 1440, and 2880 dpi. You will find differences in these settings, but they cannot be simply stated as good, better, and best. If you print an image at any one of these resolutions and give it to someone without showing them any other prints, that person will say you gave them an excellent photo print. All of these settings offer quality prints.

However, 1440 dpi does represent a noticeable increase in image quality over 720 dpi. This higher resolution will result in better tonalities, smoother broad areas of tone, and somewhat better small detail. Yet, to my eyes, stepping up to 2880 dpi does not provide as significant of a difference. Yes, if you print two images, one at 1440 dpi and one at 2880 dpi, you will see a difference. But it is a more subjective difference than an objective quality issue. Some printing engineers have told me that the human eye really doesn't see enough of a difference above 1440 dpi to make anything higher worth using. I can assure you that you will never have anyone complain that you didn't use 2880 dpi. And if you do use 2880 dpi, you will find printing time increases significantly. For that reason, I recommend you choose 1440 dpi or Best Photo for quality prints. If you really want to experiment, try all of the settings and find out if you can see enough of a difference to make using the highest printing resolution worthwhile.

Prepping an image means getting that image ready for printing, and not just viewing it on a computer monitor.

6 Prepping the Image for Printing

In Chapter 4, we established an overall workflow for printing from a program like Photoshop. In this chapter, we'll go into more detail on the steps necessary to prep an image for printing, enabling you to get the most from your prints. Plus, you'll learn more on how to get the most from using a work print. Chapters 4, 5, and 6 overlap in their content and are intended to be complementary—different readers will deal with them in their own unique ways.

Good printing is a process of learning control. It brings you into contact with your images in a way that very few color photographers have ever experienced. It similar to the type of work the traditional black-and-white photographer used to do. W. Eugene Smith is considered by many to be the father of modern photojournalism. He photographed for *Life* magazine during the 1950s, along with other important documentary work. He was known for his expressive prints that took images beyond a mere record coming directly from the camera and revealed a strong perspective on the world. I don't believe anyone who has seen his images forgets them easily.

While few of us are destined for the fame and expertise of W. Eugene Smith, we do have the potential for taking our prints to new levels of quality and expression. We can create compelling prints that grab their viewers and give them something new to experience.

The Time Needed for Printing

Getting better prints does not have to take a huge amount of time. Many people ask about this in my workshops and classes. By now, you are

probably grasping the concept that a good print starts early in the process of shooting and working on an image in the computer. But it does not have to mean spending endless amounts of time at the computer, while sacrificing time shooting.

Some people will spend a lot of time working and reworking a print. Others will make one or two prints from an image and be done. Neither approach is necessarily right or wrong—you have to find what works best for you.

Having said that, I know that some of you will be familiar with the amount of time Smith used to spend in the darkroom. Spending endless hours printing and reprinting images, he was more than a little obsessive. I can't argue with the results he obtained, but that's not my style.

Plus, he had to deal with the processing time that a darkroom demanded, time that is not necessary in the "digital darkroom." To make a single print, he would have to get the paper, make the exposure on the paper (which could take a while depending on the dodging and burning he was doing), develop it for 2 – 5 minutes, stop the development for a minute, and fix the image for five minutes—all before he could turn on the lights for any evaluation. But for a really accurate evaluation, the print would have to be washed for 15 – 20 minutes, and then dried. This whole process could take 30 – 45 minutes. This was not just for the final print, it was for every version of the image! With the "digital darkroom," you can see a new version of your image on the monitor in seconds and have a work print to evaluate within minutes.

As you begin to work with a print in hopes of making it better, you will probably spend a lot of time time at the computer. But with experience, you will get better and faster. Printing is like any craft—practice helps. I think of my sister and my daughter with knitting. My sister puts together a sweater, cap, or whatever in what seems like no time at all, whereas my daughter struggles for what seems like days. My sister makes few mistakes, and corrects those that she does make quickly. But my daughter makes more mistakes, and any mistake is a major breakdown of her workflow and can take a lot of time to correct.

So, to spend less time with printing, you have to spend more time first. You have to make and correct the mis-

takes, and learn from them. You have to learn to work intuitively and "unconsciously" with many decisions. The only way you learn is by putting in the time.

While it may take time, it is really worth it. I hear again and again from photographers who "break through" this early learning stage that they begin eagerly anticipating their prints coming off the printer. They love the experience of images turning into something tangible that they can hold and enjoy. The time spent making those prints becomes a labor of love and they develop an appreciation for this part of the wonderful art and technology known as photography.

The rest of this chapter will deal with how to make the craft of printing work better and more consistently for you. Mostly it will be about Photoshop, but nearly everything in this chapter also applies to any other image processing programs as well.

Monitor Calibration

In Chapter 4, I talked a little about monitor calibration. If that provided you with enough information to calibrate your monitor—skip this section. We are going to go into more detail as to what monitor calibration is, what it does, and how it can help make better prints.

All digital devices respond to color in unique ways. The computer may control colors in very precise ways, but how those colors are interpreted and displayed on screen (or on paper) are not consistent. For example, a monitor straight out of the box might have a bias for a certain color. You might try to remove the color cast you see, but if this only exists on the monitor, adjusting for that color imbalance will result in other colors becoming too strong. The "removal" of a color cast on the monitor can actually make a color cast appear in the print! If this occurs, you now have to try to get rid of a color problem you can't see on the monitor—that can make for very frustrating printing.

The monitor may naturally display one color "better" than others, resulting in a bias for that color. Adjusting an image on this screen means you are adjusting colors out of balance with each other, even if they really are not. The results will be a print with out-of-balance colors, even though they look fine on the monitor—again, trying to make a good print in this situation is a real time waster.

Monitor calibration is absolutely necessary for good printing. It creates a consistent, predictable digital printing workflow.

But calibration does not guarantee a good print. It just means you can trust your working environment—the monitor—to be predictable and accurate. A good print requires a lot more than this, but monitor calibration means you can get to good and better prints more rapidly and with much less frustration.

Monitor calibration today is very easy to do—buy a package of calibration software and hardware. The hardware measures the actual performance of the monitor for different colors. And after you do a few small adjustments, the software pretty much does the work for you.

There are a number of calibration packages on the market from several manufacturers, including Pantone, Datacolor, and X-Rite. The bottom line on these is that they all work. All of them will make your monitor's display more consistent and dependable. Some offer more precision in how they deal with colors, which may or may not be appropriate for you. Some people find one brand or another works better with certain monitors,

Defining the blacks, whites, and midtones greatly affects the color, contrast, and tones of an image. Notice how enhancing the blacks in the above example improves the image.

but this does not seem to be consistent enough to definitively state that one product is superior to the others.

You need to calibrate your monitor regularly. CRT monitors, which offer the best display for the cost, drift more quickly and need calibration more often. LCD monitors are more stable and need less frequent adjustments. It is hard to clearly state how often to calibrate your monitor. The frequency is highly dependent on how much the power is left on and how frequently it is displaying images. A monitor that is on constantly from morning to night, and in use the entire time, may need to be calibrated a couple of times a month for a

CRT monitor, or once a month for an LCD. But if your monitor is only on at night a couple of times a week, it might not need to be calibrated for several months.

Blacks, Whites, and Midtones

We spent some time on blacks, whites, and midtones in Chapter 4. They are absolutely critical to a good print, so I am going to spend more time on them here.

Many photographers like bright, lively colors in their prints and mistakenly go right for the saturation control to try to achieve this—avoid the temptation. Better colors result from getting better blacks, whites, and midtones in your image first. You may already know that midtones are usually the middle tones of an image. I like to simplify this by using the blacks, whites, and midtones terms because it makes it very clear what needs to be adjusted. In this context, midtones means all detailed shadows, middle tones, and highlights in a photo.

> *** NOTE...** Certain photos—such as a soft-focus, foggy, or misty scene—will not have a strong black and will actually look worse if you try to force it.

Blacks

For standard scenes, a strong, pure black must be present somewhere in an image for it to make a really good print. Without that true black the other tones will look weak and colors won't obtain their richest appearance. Remember that the plural "blacks" refers to all of the areas of pure black in a photo.

Most cameras do not automatically capture a pure black. This enables the photographer to control where the pure black appears in the tonal range of the image. In a misguided attempt to "hold detail" in dark areas, many photographers under-adjust the blacks of an image. This actually results in less contrast and color than the image warrants. Another reason why photographers under-adjust blacks is that they are trying to make sure that the image does not get too dark.

Proper adjustment of blacks must be accompanied by midtone adjustment. Changing the midtones affects the overall brightness or darkness of a print. It is the best way to adjust this aspect of the image. Weak blacks may give the appearance of a lighter print, but will result in a less than optimum print. True blacks with the proper midtone adjustment will provide you with an excellent print.

In Chapter 4, you saw how to adjust blacks in Photoshop by using Levels with the black threshold screen (obtained by pressing Alt/Option while adjusting the black slider). How much to adjust blacks depends on three things:

* **Personal preference**—some photographers like more black in their photos than others. Blacks can add a dramatic quality to an image, but they can also make it look too heavy. This is no simple decision. Bill Brandt was a famous English black-and-white photographer who loved to use very heavy blacks, giving a dense darkness to large areas of his images. He was very successful at making this work in his images. But such a look does not fit everyone's taste or needs. Many photographers prefer having just the beginnings of the true blacks in their images, and nothing more.

* **How much the photo can take the adjustment**—very strong adjustments of blacks can cause quality problems in other parts of an image. RAW files can handle more change to blacks without other tonalities breaking up. Blacks can be added to a photo through the use of specialized Photoshop techniques (such as using layer-blending options), but this technique can look artificial.

* **How much the subject can take in increased blacks**—some subjects can handle a lot of blacks without any problems, but others look bad with even the slightest increase. This decision requires a good deal of attention. You have to look at your subject very carefully and compare what it looks like with and without the added black. This is best done with an adjustment layer—you can turn it on and off quickly to see the effects.

Lightroom has a tool that activates the cursor to enable you to click and drag on specific tones for adjustment.

HINT... Use an adjustment layer, and its associated layer mask, to get the best fit of whites with your image. It is not unusual for a particular subject to need some snappy white, yet as you adjust the overall image another part of the photo might get too bright (such as a window or a background highlight). Use the layer mask to block that area by painting black over it—black in a layer mask blocks the effect of the layer in that area.

Whites

In general, most prints of everyday subjects look best with a minimum of white. But, having something pure white in the photo is what gives an image brilliance and snap. As noted in Chapter 4, you get to the white adjustment in Photoshop by using Levels with the white threshold screen (obtained by pressing the Alt/Option key while using the white slider).

Of course, there are some subjects that have a lot of white in the scene, such as a studio shot of a product against a white background. This is often adjusted with a midtone adjustment and printed as a very light gray, rather than a pure white. A very stark print can be made with a pure white background, but then special techniques (such as the use of borders) may be needed to help the viewer know where the photo begins and ends.

But for most images, finding something that is pure white is usually enough. It can be very surprising how much this will lift an image and bring it to life. This adjustment is especially dramatic if the original exposure left a gap at the right side of the histogram (meaning that all bright areas were underexposed). When whites are not at least a light gray, a photo will look flat and even a bit dead.

The key to adjusting whites is to maintain the awareness that too much manipulation can result in areas without detail. Unless you are after a special effect, this

The Color Range tool allows you to make specific tone selections and adjustments.

rarely creates a good print. Watch where the whites are in the threshold screen and be aware of what they are doing to the brightest areas of your image.

Midtones

The brightness of midtones in an image affects the appearance of correct exposure and luminance. Luminance is the quality in a good print that makes the middle tones of an image lively and open to the viewer. It can truly

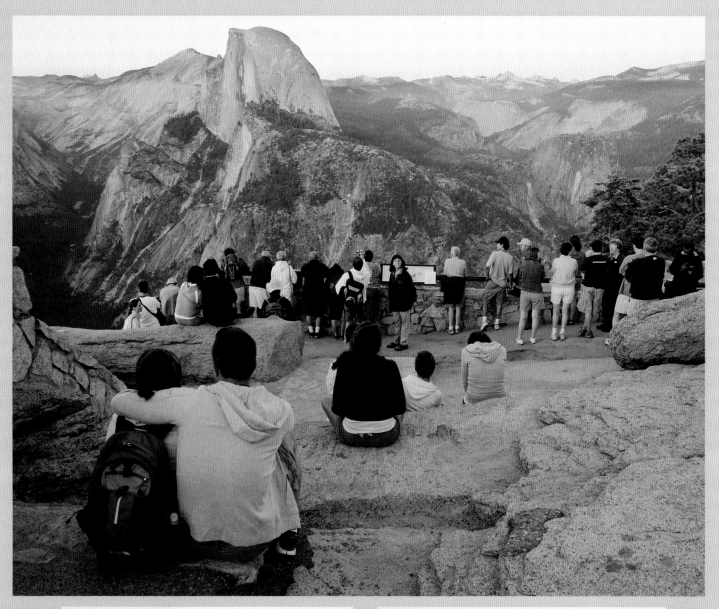

Do not simply accept how the camera renders a captured scene—its interpretation is based on arbitrary engineering and technology decisions and is not objective.

make the difference between a good, bad, or better print.

The best way to start adjusting midtones is to use Curves, as described in Chapter 4. At first, most photographers are happy to get a good-looking set of midtones that gives the image the overall brightness it deserves. This midtones adjustment may be needed to compensate for the blacks adjustment made in Levels and to bring out subject details. For many photographs, no real fancy adjustments will be needed—good luminance will happen with this simple change. However, many photographs require that the midtones are adjusted separately.

Midtones are defined in many ways. Ansel Adams used a specific series of tones to describe the various levels of brightness between black and white. Many Photoshop users like the term "quarter-tones," which break the tonalities into quarters (this can be seen in Curves when set to a quarter grid). Photographers often like the idea of detail in both shadow and highlight areas, as well as middle tones.

No matter how it is described, a good print deals with dark, middle, and light midtones. They sometimes cannot be managed with an overall adjustment to the print that does not compromise at least one of them. The Curves tool allows you to tweak these tones by adding points to the curve. You can drag a low point lower to intensify the dark areas, then drag a high point higher to lighten highlights. This is an important technique to master, but you will typically find that such adjustments need a light touch. You can have problems with tonalities looking posterized or too harsh if the curve is changed too drastically at various points.

Photoshop CS3 (and its version of Camera RAW), Photoshop Elements 5.0, and Photoshop Lightroom have all added new controls for these adjustments with Curves (or Tone Curve) that make it much easier and more intuitive for photographers to handle. Sliders, preset curves, and even highlighted adjustment areas all help.

The on-image adjustment that Lightroom pioneered is an absolutely wonderful tool for photographers who are adjusting midtones. The on-image adjustment allows you to click directly on the photo and select a part of the image with midtones that need correction, then click and drag the cursor to change them. Lightroom automatically finds the correct area on the Tone Curve to adjust and makes the tones lighter as the cursor is moved up, or darker as it is moved down. This makes dealing with midtones extremely intuitive.

When midtones need more work, you will often find it is just one area that needs attention—mainly the darks. To make these precise adjustments, select specific tones and adjust them individually with Curves. This can be done in a number of ways, but one of the best is to use the Color Range tool and adjustment layers in Photoshop.

The Color Range tool is found in the Select menu. When chosen, it provides a dialog box of choices. This tool has a great deal of power, but full descriptions of all of its uses are beyond the parameters of this book. A very quick, easy, and quite effective way of using it is to click on Select Area (the little arrow at the right) to open the drop-down menu. This menu gives you a set of choices, including Highlights, Midtones, and Shadows. You can choose any of these and click okay to have Photoshop select these tones in your photograph. Now add a Curves adjustment layer, and a layer mask is automatically created based on this selection. Any adjustment with this Curves layer will now mainly affect those tones specified by the Color Range tool. This gives you tremendous power to really work the midtones of an image for a great print.

Color

Going from a good print to a better print means paying close attention to what is happening to the color. I am not going to go into a lot of new techniques because they are not necessary. This is not discrediting those

A color cast can greatly detract from a print's appeal, but is easily correctable.

photographers who use very specialized techniques. Rather, it is to point out that these simple techniques work for photographers, and gaining experience with them will do more for you than learning a lot of other techniques.

Color Correction

Wrong color tones can really kill a nice photograph. Color casts can make skin tones look unhealthy, flowers ugly, and landscapes unappealing. This is where a calibrated monitor is truly necessary—without one, you will not be able to see the color casts properly.

Color casts in an image make the photo look like a television set that hasn't been properly adjusted. If you go to an electronics store and see all of the television sets next to each other, you can tell if the color on one of them is off-balance. Sometimes it is clear that there is too much yellow, or not enough red, in a picture. But other times, you know the photo doesn't quite look right, but you are not sure exactly where the adjustments need to be made.

I like the technique described in Chapter 4 because it is so easy to do and really based in photography. It simply requires you to click on something in the photo that should be neutral in tone (white, gray, black—it doesn't matter) and the program does the work for you, making the tone a true neutral by correcting the color problem. This works with essentially the same tool in Camera RAW, Photoshop, Photoshop Elements, and Lightroom (though the tool is found in different places).

Step-by-step, here is the optimum way of color correcting your image using Levels in Photoshop:

✳ Add a Levels adjustment layer and open the Levels dialog box.

✳ Click on the middle gray eyedropper to select it (called the Gray Point eyedropper here).

✳ Move your cursor onto the photograph and begin clicking. Look for tones that should be neutral, but don't be afraid of hurting anything (you can't). You may have to try many locations, or you may get lucky with just one.

Adobe Camera RAW (top) and Lightroom (bottom) have white balance tools that allow you to click on something in the image that should be neutral in color to correct it.

✽ If the adjustment looks really bad, try resetting the dialog box by holding down Alt/Option and clicking on the Reset button which then shows up, and start over.

✽ Get close to the color that you feel is best, then adjust the Opacity of the layer for a final tweaking of the color.

In Camera RAW, this same eyedropper exists, but it is all by itself in the toolbox and is called the White Balance tool. (So much for consistency among Adobe products, but I do give them credit for using a more accurate name here.) The White Balance tool is used in the same way as the eyedropper—by clicking around the photo on tones that should be neutral in color. Lightroom also has a White Balance tool that works the same way; it is in the Basic section of the Develop module.

Color Adjustment

Photos do not necessarily need color adjustment at this point—some will, some won't. The adjustments of blacks, whites, midtones, and color correction made up to this point may be all that is needed to achieve a great print.

Many photographers like a little more saturation in certain subjects, such as landscapes or flowers, than their camera may have originally captured. In addition, you may find that certain colors have recorded poorly, while others look fine. These are the types of situations that warrant further color adjustments.

A lot of photographers are accustomed to brighter colors in their photos because many film types—especially print films—used to really accentuate colors. In an attempt to mimic these results they often turn to the saturation control of Hue/Saturation. Commonly they do this too early in the process and they use it too strongly. Saturation needs a gentle touch or it will quickly make a photo look garish. Use the saturation control conservatively. A heavy hand here will cause colors to block up, obscure detail, and take colors out of the range of attractiveness.

If you use an overall Saturation adjustment, I would recommend keeping the changes at 10 – 15 points or lower. If you need to bring up weak colors, you might try the Vibrance control in Camera RAW or Lightroom. It is a less heavy-handed control than Saturation.

The best way to handle color saturation adjustments is to concentrate on affecting only the colors that really need it. Try the following with Photoshop's Hue/ Saturation control:

✽ **Open Hue/Saturation as an adjustment layer**– using the layer is really helpful because you will often find the need to go back and readjust a certain color as the image is printed. An adjustment layer allows you to do this with no harm to the pixels of the photo—the adjustment layer is only a layer of instructions.

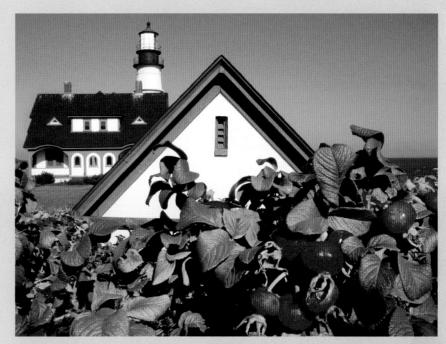

✳ **Click on the Edit drop-down menu**–(it is usually set to "Master") in Photoshop's Hue/Saturation dialog to get a selection of colors. Select a color. This provides a color graph at the bottom of the dialog box that shows where your color will be adjusted (inside the black markings along the color bar). Only the selected colors are affected.

✳ **Refine the color selection**–by moving your cursor onto the photo and clicking on the color you want to adjust. Photoshop will change the limits of that color adjustment and you will see the color bar change in response. You can also hold down the shift key to add colors to that limited area.

✳ **Adjust the saturation for optimum appearance**–by moving the slider, as needed. You can now increase certain colors quite a lot without hurting the photo—in fact, you may find this is the best way to adjust problem colors.

You may also need to adjust a specific color's hue. For instance, it is not uncommon for flowers to have colors that recorded inaccurately, or for clothing to have the wrong hue. Follow the same procedure as described above for saturation, but now you use the Hue slider.

Camera RAW works similarly with a tab specifically for hue and saturation adjustments. This is exactly like Hue/Saturation, except the whole set of colors (with adjustment sliders) are displayed at one time, instead of individually. You can adjust individual colors as needed, but you can't refine

When working with the Hue/Saturation tool, adjust the specific colors rather than attempting to adjust everything with one slider.

Adjustment layers and layer masks allow greater control in image adjustment and bring out detail that otherwise might not print well.

your choice by clicking on the photo (for that reason, you may find this easier to do in Photoshop).

Lightroom works similarly, but adds a great twist. You can set up your cursor so that you can click on a color in a photo and have the program find the right color (or colors) to adjust. Then you simply click and drag on that color in the photo to change the hue or saturation. This is a very intuitive way to adjust color.

Local Adjustments

The visual balance of tonalities and colors greatly affect a print. While overall adjustments are critical, small area adjustments can make a huge difference in how well a print works as a photograph. These local area adjustments can involve the darkening of an overly bright corner or the correction of a person's skin tone in the shade. The key is that nothing

else in the photograph is affected by these changes.

Ansel Adams spent a great deal of time on this concept in his photo how-to books. These books are a great resource if you want to learn more about this idea. I can only introduce the idea here, although I will discuss one form of local adjustment—edge darkening—next. Making local adjustments can only be done in programs like Photoshop, where you have the ability to selectively make adjustments in one place and limit those adjustments so they do not appear anywhere else. This requires the use of selections or layers available only in these programs.

While local adjustments are the equivalent of dodging and burning in the traditional darkroom, the Dodge and Burn tools in Photoshop are not the right tools to use for this effect. They will work for very small areas, but you will run into three problems if trying use then. First, they have to be used on a pixel-based layer. Second, they only really work well over very small areas; large areas will become blotchy and produce uneven results. And finally, once you have made the adjustments, they cannot be easily changed without some special layer techniques.

Here's how to make local adjustments in an image:

❊ Examine your photo for imbalances. Look for areas that are too bright, too dark, or the wrong color compared to the rest of the image.

❊ Use adjustment layers to make corrections for these areas.

❊ Use Curves for brightness and contrast changes, the Gray Point of Levels for color correction, and Hue/Saturation for color changes.

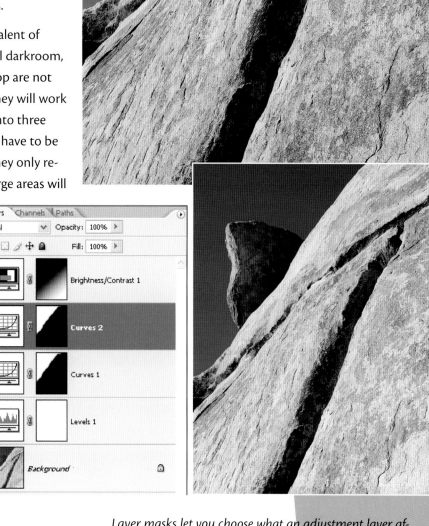

Layer masks let you choose what an adjustment layer affects in the image. You can block out an adjustment you don't like, or allow an adjustment to affect just a small area of the photo.

In this example, there are two Brightness/ Contrast adjustment layers with masks controlling the edge brightness—the "edge burning" of the traditional darkroom.

✳ To limit the adjustment to the specific places that need it, use the layer mask for the adjustment layer.

✳ Use a separate adjustment layer for each local adjustment. Don't try to do them all in one layer.

✳ Paint in your adjustments on the layer mask—use black to block the effect of the adjustment, white to allow it.

✳ A good way to make a change is to apply the right adjustment for the local area over the whole image first, ignoring what happens to the rest of the photo. Then fill the layer mask with black (Edit menu>Fill>Select Black for color). This blocks the effect and you can paint in the effect over the area that actually needs it.

✳ Selections can be used to limit adjustments to these areas, but you can cause quality problems in the long run if you do this to the pixels.

✳ Selections work very well when used with adjustment layers. Select the area you want to adjust before adding an adjustment layer. Then when you add that

layer, a layer mask is automatically created based on the selection.

✳ Use Gaussian Blur on a layer mask to help your adjustments blend better.

Edge Burning

Early in my photographic career, I sat down and read all of the Ansel Adams books on photographic technique. As I've mentioned, Adams was a superb printer. If you ever get a chance to see one of his photographic prints at a museum, you will see the work of a true master. His books cover the art of printing in great detail.

One important factor that Adams stressed was controlling the brightness of the edges of the print. He felt, as have many master black-and-white printers, that the edges should be darkened to keep the eye in the photo. On most photos, Adams would spend time burning in (darkening) some or all of the edges to refine his print. Although I have seen some of his prints that had very heavy edge burning, Adams did it so masterfully that most people don't notice that he used this technique.

For "edge burning" our prints in the "digital darkroom," we need to use adjustment layers and their layer masks. This technique will give you edge darkening that is never blotchy and is actually easier than using the Burn Tool. Here are the steps:

1. Add a Brightness/Contrast adjustment layer.

I know, I know—all the Photoshop experts say never to use Brightness/Contrast. And for most adjustments to an image, they are right. Brightness/Contrast is a rather heavy-handed tool and makes everything brighter or darker. There is no subtlety or precision control here, which is exactly what is needed for this technique. We want the outside edges of the photo to be darkened consistently.

2. Darken the whole image by about -20 points.

The amount is not critical. With experience, you'll get better at guessing this amount, but for now, realize that the Brightness/Contrast adjustment layer can be readjusted to any amount. And because you can change its opacity, you have plenty of control.

3. Fill the layer mask with black.

The black will block the darkening effect. In Photoshop, use Edit>Fill>Black.

4. Paint in the darkening effect.

Use a very large and soft paintbrush with white. Paint in the corners and all along the edges. Paint in any area that looks better darkened. White allows the effect, so by painting white into the layer mask, you are allowing the darkening effect of Brightness/Contrast to work.

5. Change the Brightness/Contrast control as needed.

You can readjust the strength of the adjustment by reopening the Brightness/Contrast dialog box or using the opacity control. Now, turn the layer on and off and you will be amazed at the change. The darkened image adds more depth and richness to the photo, while the undarkened image just doesn't look right!

6. Use a selection.

You can also use a selection to control the layer mask for this effect. Make a selection all around your subject, then invert the selection so the active area is at the edges. Now add the Brightness/Contrast layer and a layer mask is created for the selection. This mask will be too sharp edged, so use Gaussian blur to blend it.

Black Line Borders

People used to spend hours filing their negative carriers to achieve this look. But with digital it is easy. This creates a border that often enhances a print because it is a simple black line around the edges of the image. This is especially true for light images or photos that have large areas of white near the edge of the frame. In

✳ Adjust the size of the stroke to fit what looks good to you. Generally, just a few pixels works, but this should be determined by the final print size.

This technique will cut into the photo very slightly—with a narrow line, this usually won't cause any problems.

Evaluating Your Work Print

The concept of the work print was addressed in Chapter 4. If you remember, this print is an important step for going from good to better to great in your final print. A lot of work prints are not necessary, but approaching your first prints by looking at them as work prints will help you really see what is needed to make them better.

So what do you look for in a work print? How do you evaluate it? Then what do you do with the information?

addition, a simple black line border is an effective way to define the area of a photo on a page.

To create this border using Photoshop follow these steps:

✳ Make a layer of your image by double-clicking on the background layer of a flattened photo in the layer palette. If your file is already layered, click on the top layer then hold down Shift + Alt (or Option) + Ctrl (or Cmd) and then press E (with older versions of Photoshop, you might have to press N first).

✳ Double-click that layer (or use the Layer Styles icon at the bottom of the Layers palette) to get the Layer Styles menu.

✳ Select the Stroke option.

✳ Change the color to black.

✳ Set the position to inside.

I'll answer the last question first. You go back and make adjustments to your photo using the techniques discussed in this chapter until you get the print you really want. This is one of the greatest advantages to using adjustment layers. Sometimes you will actually discover you want to make an adjustment because of what you see on the work print, an adjustment that you never thought of while the image was on screen. And sometimes you may want to try some wild adjustments, just to see what they will do to a print. This type of experimenting can give you a lot of good information.

You can also add adjustment layers to the photo to make corrections based on what you see in a work print. This is an ideal way to work because you are not making permanent adjustments or changing pixels—keeping your image quality high.

When you examine a print as a work print, here are

some things to consider (you'll notice they follow many of the guidelines you've already learned in this chapter):

✳ **Check the blacks**–are the blacks in the image appropriate? Are they dark grays instead of true blacks? Are the areas of blacks too large or too small? How is the subject affected by the amount of black in the scene?

✳ **Check the whites**–are the whites in the image appropriate in both tonality and size? Do you have detail in the bright areas where it is needed? How do the brightest areas of the image affect the overall photo?

✳ **Examine the midtones**–does the overall print look too bright or too dark? Do the dark areas have the right balance of darkness and visible detail? Do the bright areas have the appropriate brightness to maintain their detail? Do the middle tones have life and form, being neither too heavy nor too light in tonality?

✳ **Compare the overall image brightness and contrast with local areas**–are there places that are too bright in comparison to the overall tonality? Or places that are too dark for the overall print brightness?

✳ **Look at the overall color cast of the image**–is it appropriate for the scene? Is it too cold or warm for a good print? Is too much of any color pervading all parts of the print?

✳ **Check the color saturation and hue of your key colors**–this can be very important. We see many colors in specific ways, such as green grass or blue skies. If those colors in a print do not match our expectations, the photograph won't look right.

✳ **Examine the whole photo for areas of local color imbalances.**

✳ **Look for problems with noise**–big problems will require special software such as Kodak Digital GEM or Imagenomic Noiseware.

✳ **Look for sharpness issues.**

✳ **Make corrections and reprint as needed.**

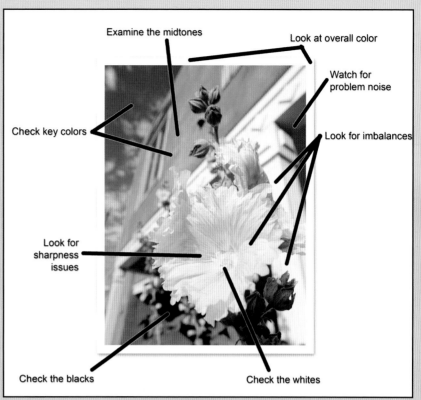

Examine the midtones · Look at overall color · Watch for problem noise · Check key colors · Look for imbalances · Look for sharpness issues · Check the blacks · Check the whites

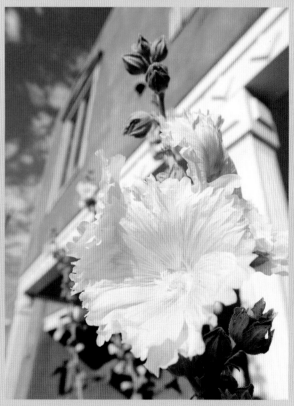

Evaluating a print depends on many different criteria, but is not about comparing it to the monitor, as we have discussed, but how it works on its own.

BOB KRIST

TRAVEL MASTER

You might never have seen his face, but you have certainly seen his photographs. Bob Krist, whose work has taken him to all seven continents, is a premier travel photographer for National Geographic Traveler and Islands Magazine. He has won awards in the Pictures of the Year, Communication Arts, and World Press Photo competitions, and was twice named "Travel Photographer of the Year" by the Society of American Travel Writers, in 1994 and 2007. Krist has authored articles and books, and his work shows up in guidebooks to locations around the world.

For Krist, Epson ink jet photo printers have eliminated the very costly and slow process of getting prints made. Krist says he didn't have prints hanging up in his house and office before ink jet printers, but now it is easy for him to "whip out a great looking print with relative ease."

This flexibility allows Krist to use prints for many purposes or uses and in different sizes, mostly 8.5 x 11

inches (21.6 x 27.9 cm) or 13 x 19 inches (33 x 48.3 cm). "I make a lot of 'thank you' prints for photo subjects from my magazine and book assignments, and it is great karma," he says.

He prefers to print on Enhanced Matte or Premium Luster for photos that he sells or exhibits. For Krist, the best things about ink jet printing are the immediacy and the control of the final product. On the other hand, he says he sometimes can get too wrapped up in making prints and forget to finish more important tasks like column deadlines and bookkeeping chores (and we probably all relate to that in some way).

Krist works with a number of Epson printers, including the Epson Stylus Pro 3800 for large prints and the Stylus

Photo R1900 for printing quick prints, invoices, letters, and other small jobs.

When it comes to printing advice for photographers, Krist says, "My first tip would be to profile your monitor." He strongly suggests getting a good colorimeter and creating a profile for the monitor, and urges photographers to make sure they have spare ink cartridges; after all, "nothing is worse than running out of ink in the middle of a printing session." Lastly, he says photographers should take advantage of the new drivers and tutorials Epson provides on their website, which are filled with helpful advice.

You can view Krist's work on his website, www.bobkrist.com.

Sizing and sharpening a photograph are keys to getting a beautiful print.

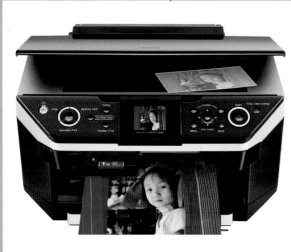

Sizing and Sharpening

In the digital world, an image must be sized properly in order to make a print. Pixels by themselves have no dimensions, other than the number of pixels. There needs to be some sort of size reference, in terms of how the pixels are spaced, for the printer to produce a print.

Sizing and sharpening was briefly addressed in Chapter 4 and was not included in Chapter 6. This is because while sizing and sharpening an image are critical to getting a good print, it is best done after you are finished working on an image.

Many students of mine have asked why you should wait to sharpen your image. After all, doesn't it make sense to sharpen a photo right away so you can see it in its full glory? Perhaps, but there are three problems that can come from sharpening an image early on:

First, your best results come from sharpening an image specifically sized for a print. Small changes in size are not a big deal, but big changes are. If you size an already sharpened photo, sharpening artifacts will also be sized, and thus "enhanced." To avoid this you want an unsharpened master file that can be used at any size. Size from it and then sharpen the image.

Second, as you work an image in a program like Photoshop, the changes you make can affect the appearance of sharpness. This can make early sharpening look bad later on.

Third, sharpening can intensify noise, which is further enhanced as you process the photo.

It is sort of like saying you are going 60 miles per hour, so how long will it take to get there? Without knowing the distance to where "there" is, this is an unanswerable question. The printer needs to know how big to make an image and how to space the pixels based on the data it is getting about that image. An image file size, such as 4000 x 3000 pixels, tells you nothing about how the image will print without knowing the spacing (ppi) of the pixels.

Therefore, every photo must be sized before it can be printed. It must be optimally sized for the printer, as well as the pixel data in the file. Sizing may mean the photo gets more pixels, or has to have pixels removed. Regardless, the photo must be sized for the specific usage. For this reason, you will frequently need to create multiple image files based on the different sizes of prints you desire. For example, you might need a large file for a 12 x 18 (30.5 x 45.7 cm) print, a small file for email, and the master file for any future sizing.

To size an image for printing, first make sure your image has a printable resolution. A printing resolution is anything between 200 and 360 ppi at the size printed. Lower numbers will not give you the data needed for an optimum print and, believe it or not, neither will higher numbers.

Most resizing tools act like Photoshop's Resize dialog box. There are three parts to this control:

✳ **Pixel Dimensions** – the size of the image based on its pixels. Pixel Dimensions also tells you if the number of pixels in the photo (and file size) are increasing or decreasing.

Sizing the Image

Sizing is a pretty basic operation with no tricky techniques for photographers to master. Photoshop and other Adobe products have greatly simplified sizing because the program does the math for you. This section will repeat some of the overview of sizing found in Chapter 4 and add some additional information.

If sizing is such a simple process, you may wonder why the emphasis is placed on it here. Size is a very specific part of the printing process that many photographers don't understand. Sizing is something you should do at the end of your work on an image in Photoshop, just before you print. A print needs a certain linear image resolution (such as 200 ppi), but that number is meaningless without a physical size, such as 5 x 7 inches (12.7 x 17. 8 cm) or 12 x 18 inches (30.5 x 45.7 cm).

✳ **Document Size** – this is the actual printing dimensions of the file. It specifically tells you how big the print will be with a particular resolution (ppi).

✳ **Resample** – this lets you choose to use either the native (original) resolution of your image file and resize only by how close or apart pixels are or use a new resolution (interpolation). When the Resample box is checked a new resolution will be created.

Here's how you size an image using the Photoshop sizing dialog box:

✳ Open the Resize dialog box (Image>Resize).

✳ Uncheck Resample. The first thing you want to do is determine how big or small the photo can be without altering (interpolating) pixels.

✳ Type in 200 for ppi. This shows the largest print size the image can be with the existing pixels.

✳ Type in 360. This shows the smallest print size the image can be with the native pixels.

✳ If the size you want to print your image falls within this range, then simply plug in a dimension you want in the width or height boxes—you cannot change the dimensions of the image to a specific size at this point. To do that, set one edge of the image to the shortest dimension you need and Photoshop determines the other dimension. This photo can then be cropped to the specific size needed.

✳ If your image needs to be bigger then the largest size possible from the native pixels, type in 200 ppi, then check Resample. Type in the needed physical dimensions to get to the size you want, and check Bicubic Smoother (designed to smooth out pixel interpolation and enlarge a digital file better).

✳ If your image needs to be smaller then the smallest size possible from the native pixels, type in 360 ppi, then check Resample. Once again, type in the needed

Photoshop's Image Size dialog box has three key components: Pixel Dimensions, Document Size, and Resampling.

physical dimensions to get to the size you want, but this time check Bicubic Sharper (designed to maintain detail as a file size shrinks and loses data).

✱ Make sure Constrain Proportions remains checked. This means that if you make one dimension larger, the other will automatically be enlarged in proportion to the original frame. It will also keep the image in proportion if the image size is reduced.

There are other sizing tools available on the market today, but the sizing algorithms of Photoshop are quite good and were updated with the CS models of the program. Alien Skin Blow-Up and OnOne Genuine Fractals are very good programs for significantly enlarging digital files while maintaining great quality. I have not found a huge benefit with using these programs instead of the Photoshop CS versions when file sizes are not being greatly increased (prints 12 x 18 (30.5 x 45.7 cm) or smaller, for example), but they do offer an improvement when creating files for very large prints.

Sharpening the Image

Sharpening is a critical part of the digital process, yet it is often misunderstood, leading to inappropriate sharpening of photos. Sharpening is about getting the most from a properly focused photo, it is not about making something out-of-focus sharp. What sharpening does is bring out the fine details in a file and creates beautiful, sharp prints.

It is very important to understand that sharpening has nothing to do with making an out-of-focus or blurry image sharp. Many photographers will over sharpen a photo while trying to make soft parts look better. This does not work and simply makes the print look harsh.

Digital camera files do not achieve their maximum sharpness when they come directly from the sensor. This is due to a number of factors related to the physics of sensors. If you scan an image, the scanning process also does not automatically sharpen the image to its fullest potential. Cameras and scanners will often allow you to do some sharpening when the image is actually recorded, but this might not give the best results. The image has to be sharpened in post-production in order for it to look as good as when the lens originally created the image on the sensor.

If you research this subject, you will find there are many formulas and ideas for sharpening. Frankly, they all work, but not necessarily for every photographer. A sharpening technique perfect for a rocky landscape may be inappropriate for a foggy seascape; the subject matter has a relationship to the relative sharpness needed in the image. Sharpening is also very subjective. Some photographers like the effect of stronger sharpening more than others. This is why different ideas about sharpening can be correct and

appropriate, each for its specific situation.

There are three important reasons that are worth repeating regarding why you will want to sharpen your file just before printing and not at any other time:

✱ **The appearance of sharpness is affected by image processing**–if you sharpen too soon, you can end up sharpening the wrong amount.

✱ **Sharpening is best when based on the final print size**–you get the best results by adjusting the settings for a specific print size.

✱ **Sharpening too early can adversely affect image artifacts**–added processing can make them look worse.

Unsharp Mask is the most important tool to understand and use for sharpening. But, the name is a little misleading, because unsharp is in the name many people conclude that it can be used to make blurry pictures sharp, which is not the case. Photoshop was originally designed for people in the commercial design and printing industries—people who use photography but are not necessarily photographers themselves. The name Unsharp Mask is left over from a process used in the commercial printing industry. Black-and-white half-tone printing (a common way photographs are printed in publications) includes a technique where a slightly blurred image is placed against the sharp image in such a way that the original photo actually looks sharper. Something similar happens when the Unsharp Mask sharpening tool is used.

Sharpening works best on images that are properly exposed and well-focused—sharpening enhances important details.

Unsharp Mask, often abbreviated as USM, continues to be a key sharpening tool after many years of use because its three variable controls (Amount, Radius, and Threshold) make it an extremely flexible tool. To help you get started, I will give you some numbers and ways of using these three controls. Again, you will find various formulas for these numbers that all work, but the numbers I provide offer a good starting point for prints.

Before I go over how to set up all three of these sharpening controls for your photographs, I want to cover one very important aspect of sharpening: The use of Radius in Unsharp Mask and other sharpening tools. Sharpening affects the details in places where there is contrast along an edge (which is what sharpness is based on). Radius determines the actual area of where the sharpening will occur. Setting the Radius tells the program how far to look for this contrast, and is strongly influenced by the size of the photo.

Unsharp Mask is an important sharpening tool in most image processing programs. It has three important variable components: Amount, Radius, and Threshold. Each component plays a role in determining what pixels to sharpen and how they will look after USM is applied.

However, sharpness also depends on controlling very small details in a photo. This means that Radius can never be very large for general sharpening. There is little point in having the program define sharpness within a photo beyond a couple of pixels in Radius. There are some special purposes for using a high Radius, but they are beyond the scope of this book.

A large photo has more pixels, so theoretically you need slightly more Radius then you would when producing the same effect in a smaller photo. I generally use a radius between 1 and 1.5 for most images, going up to 2 for a very large print (more than 30MB file) and going to less than 1 for a very small print (6MB file or less). I also vary the amount of radius depending on the subject—I may use a radius of less than 1 for subjects that don't need a lot of sharpening.

Changing Radius numbers will affect something called "halos." Halos usually appear as rings of light around sharpened, contrasty edges. You need to be careful of the presence of halos in your image. To see how halos can affect your image, set Radius high and watch what happens near contrasty edges of detail in the photo as you increase Amount. The resulting band of contrasting tonality can make a print look harsh and unnatural.

The numbers I gave you represent a more aggressive use of Radius than some photographers like; there is a danger of unsightly halos of brightness around strongly contrasted edges. To be sure they do not get halos,

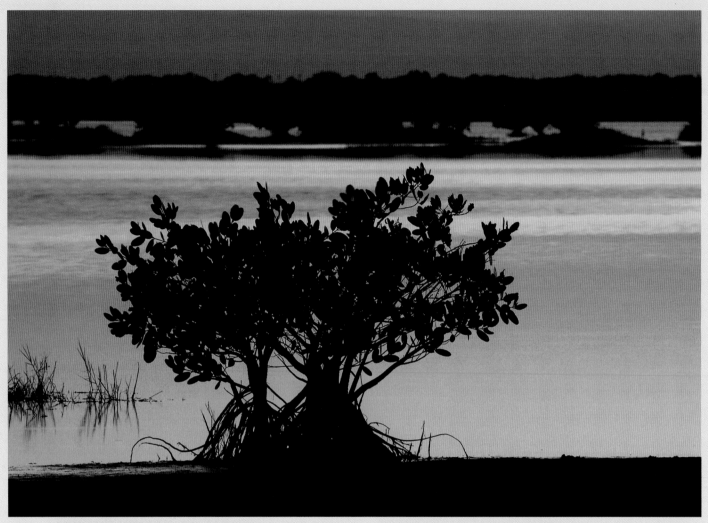

When you are sharpening an image, watch closely for halos—created by too much sharpening—in the high contrast areas (see the detail shot on the right). These edges make a photo look harsh and overly processed.

many photographers set Radius about half of what I suggest. So why do I like the higher settings? They do something very interesting to a print by intensifying tiny highlights, which gives the print a stronger feeling of brilliance and snap.

Brilliance is complementary to sharpening, but it is not the same thing. Top lenses from the best manufacturers often have a level of brilliance that gives an image snap and sparkle that lower-priced lenses can't match, even though the lens may have similar resolution (sharpness). Brilliance is not something you necessarily want to exaggerate when printing portraits (it makes the skin surface and texture more obvious), but it really helps landscapes and other nature photography.

As Radius increases, tiny specks of bright highlights intensify—this is similar to a small-scale version of the halo problem, but in this case it helps the photo. If you have a large, high resolution monitor, you will be able to see this in the overall image on your screen. This is also why I do not enlarge the main image I am working with to 100%; you wouldn't be able to see the Brilliance effect. However, I watch the 100% image preview in the Unsharp Mask box to make sure I am not creating halo problems.

It is important that we return to the controls for USM (Amount, Radius, and Threshold) and really recognize and understand how they work together. Once you have seen many formulas for USM, you will notice that as one changes, the others also change, balancing them out. As noted above, Amount and Radius are especially dependent on one another. Any number for Amount, for example, is meaningless without knowing Radius. Here are some ideas on how to set these controls:

✳ **Amount**–amount is the intensity of the sharpening. It needs to be higher when detail is fine, radius is low, and any time you need more sharpness from a subject. (Again, you can't get sharpness from a blurred photo—increasing Amount on such a photo will make it look bad.) You will generally use higher settings for highly detailed subjects such as rocky landscapes, and lower settings for gentle subjects such as flowers. I like Amount set between 130 – 180 for nature subjects, something in the range of 150 – 190 for architecture, and a setting of 100 – 130 for people.

✳ **Radius**–radius is described in detail above, but to summarize, it tells the program how far to look for a change in contrast, determining what area will be intensified (Amount). I generally use a Radius between 1 and 1.5 for most images, going up to 2 for a very large print (more than 30MB file) and going to less than 1 for small prints (6MB file or less). Some photographers who really worry about halo effects will use a higher Amount with a lower Radius, such as 250 with 0.7, but, as described above, the trade off is less brilliance in the print.

✳ **Threshold**–threshold affects when the sharpening will actually occur, based on the contrast of an edge. A low Threshold gives high sharpness, because it sharpens everything that exhibits a change in contrast. Something to think about when considering Threshold is the fact that noise and other image artifacts show up because they have contrast differences. A low Threshold allows the sharpening effect to sharpen noise and other artifacts, which is generally undesirable. On the other hand, a high threshold reduces small detail sharpness. For most digital cameras, I set Threshold to 3 – 4. I will increase this up to 10 – 12 if I find any noise problems, but never higher. I look for grain in scanned images to set Threshold with film. Again, I never go above 10 – 12, but use low numbers whenever I can. You can see what Threshold you might need by checking a smooth area of the photo (sky, out-of-focus areas, etc.) at a 100% preview or higher. In Photoshop, you can simply click on an area like this with the cursor and that location will be shown in the 100% preview in the sharpening dialog box.

UNSHARP MASK CONTROLS

Setting	What it does	Range to try
Amount	Controls degree of sharpening	130 – 180
Radius	Where sharpening occurs at the pixel level	1 – 1.5
Threshold	Affects the sharpness (and appearance) of noise	3 – 4 (most) to 12 (noisy)

Smart Sharpen was introduced in Photoshop CS2 and uses new algorithms for sharpening compared to USM. Its controls work similarly to USM—allowing you to set Amount and Radius—but it has better compensation for unwanted halos and other artifacts. It works very well to bring out maximum sharpness from a photo, though I rarely use it.

The problem with Smart Sharpen is that it has no Threshold setting. That means it often sharpens noise inappropriately and there is nothing you can do to control it. That is a severe limitation to me and stops me from using it as my main sharpening tool. I use it on a restricted basis on images that need its better sharpening technology, but won't be hurt by the lack of a threshold adjustment.

There are some independent software programs made to make sharpening either more intuitive or make it work better. One popular program is Nik Software Sharpener Pro, which can be very helpful for printing. This is a Photoshop plug-in (though it also works in other programs, including Photoshop Elements). Sharpener Pro does some nice automated sharpening for specific printer types, print sizes, and viewing distances. And you don't have to know anything about USM settings, because it doesn't use them. It uses more intuitive terms like size and viewing distance. It also uses some advanced sharpening algorithms.

But the biggest benefit of Sharpener Pro comes from its Advanced settings. In these settings you can tell the program how much to sharpen areas based on their colors and tones. This allows you, for example, to not sharpen a color or tone that has a lot of noise (very often noise is most common in specific colors or tones). The program very smartly finds these specific areas and sharpens only what you tell it to, as well as how much to sharpen each area. It also does a nice job with tiny highlights, accentuating image brilliance.

A photo should be sharpened based on its printed size. Size has a big effect on what details show up in a photo and how the image should be sharpened. This is especially true with Radius choices, as noted above. Therefore, a photo should be sized before sharpening. This means you will need multiple copies of a photo on your hard drive if you are making different sized prints from an image.

Many photographers don't like this; they want to be able to take one file and print from it in all sizes. This is not possible if you want optimum quality. If you enlarge or reduce an image from an already sharpened file, two problems can occur—first, you will adversely affect sharpened areas, creating or inappropriately enhancing sharpening artifacts; second, you will not be sharpening the important details for the selected size because you will have sharpened details for a size not being used.

Photoshop's Smart Sharpen tool uses newer algorithms for sharpening, but the controls are virtually the same as USM. It is best to use on images with very little or no noise, as it does not have a Threshold control.

If you are not making too much of a change in an image's size, you can probably get away with enlarging an already sharpened file (i.e. going from 8 x 12 (20.3 x 30.5 cm) to 11 x 14 (27.9 x 35.6 cm)). However, this is not true when you make big changes; if you go from an 8 x 12 (20.3 x 30.5 cm) print to a 12 x 18 (30.5 x 45.7 cm) or a 4 x 6 (10.2 x 15.2 cm) print, you will encounter problems.

✴ HINT... I highly recommend you keep a master file of your photo that is based on the original native pixels from the camera and has not been sharpened. This is an image you have already processed and is ready to go as a print; it just needs sizing and sharpening. I keep my master file as a Photoshop file (PSD) with its attendant layers. Then I create new files at specific sharpened sizes as TIFF files. I include the size of the print in the name so I know it is a sized and sharpened file (i.e. MN-CascadeRiver-12x18.tif).

Selective and Overall Sharpening

Many photos can have problems with overall sharpening and, as previously discussed, sharpening out-of-focus areas offers no benefits. To create a great print with optimum sharpening, you need to examine your image to see if it would be better with overall sharpening or selective sharpening. Overall sharpening is simply applying sharpening to the whole image. Selective sharpening is sharpening only specific parts of the photo.

✴ Overall sharpening – you should sharpen the image overall anytime the photo is filled with focused detail, has a lot of depth of field, or is more about detail than soft focus. You will not need any special

techniques beyond what was already described.

✱ **Selective sharpening** – you need to consider selective sharpening when a photo has large areas of blurred, out-of-focus tonalities and colors, is selectively focused to begin with, or has certain areas with a lot of noise. There is no point in sharpening out-of-focus areas. In fact, this can make them look unnatural and increase the appearance of noise.

The easiest way to selectively sharpen a photo is to use layers. The following steps will show you how:

✱ Copy your photo to a new layer so that you have two identical images on two separate layers.

✱ Sharpen the entire top layer so that whatever needs to be sharp is sharp, ignoring what happens to the other parts of the photo.

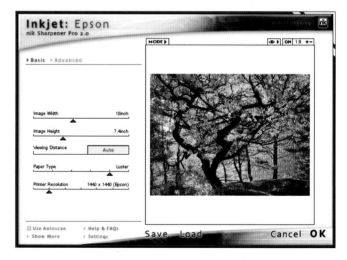

Nik Sharpener Pro is a Photoshop plugin that simplifies the sharpening step.

❊ Limit the sharpness in the top layer to just the areas you need sharpened. There are two ways of doing this—the preferred method is to use a layer mask, but an easy way is by erasing.

❊ **Layer mask** – add a layer mask to the top layer and fill it with black (Fill>Black) to black out that layer's sharpness. Now use a soft, white paintbrush to allow the sharpness to come through only in the areas where it is needed. Change the size of the paintbrush as needed to match the subject.

❊ **Erasing** – use a large soft brush to remove parts of the top layer that don't need to be sharpened. Change the size of the brush as you get close to the subject.

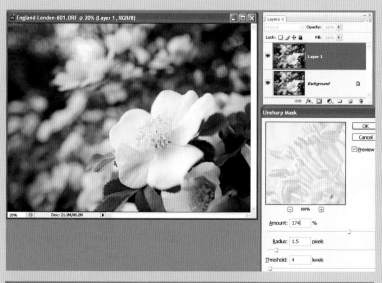

You can selectively sharpen an image using a sharpening adjustment layer and a layer mask. The mask allows you to "hide" the areas that you do not wish to sharpen.

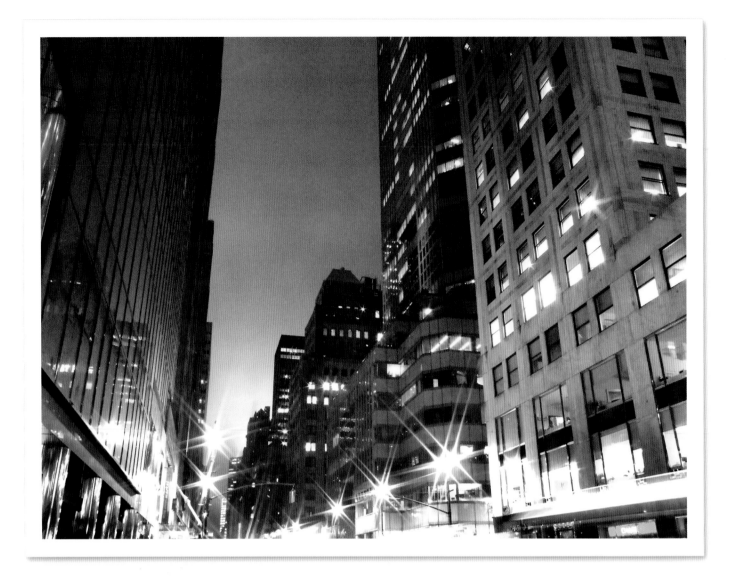

Long exposures and high ISO settings can mean increased noise in an image, especially in a night scene.

Noise Management

Noise has been mentioned several times in this and earlier chapters. Now is an appropriate time to discuss noise in more detail, because its appearance is strongly affected by the size and sharpness of an image.

Grain has been a part of photography since the beginning, but became really important when film formats were reduced with the introduction of 35mm film. Grain is the appearance of the actual texture of the film in the printed image. Noise is the digital equivalent of grain. Sometimes we find we have too much grain or noise in an image, yet other times we want to increase it for particular creative effects. Either way, grain or

noise has a strong impact on how a print looks.

Visually, the irregular speckled pattern of either is distracting and can even destroy a good photograph. It is important to pay attention to noise because it can be inadvertently increased or enhanced while working on a photo in the computer.

Here are common places for noise (or grain) to rear its ugly head in prints, and some ways to reduce it:

Sensor Noise

✳ Digital camera sensors can generate noise. This happens with all sensors in low light and long exposure

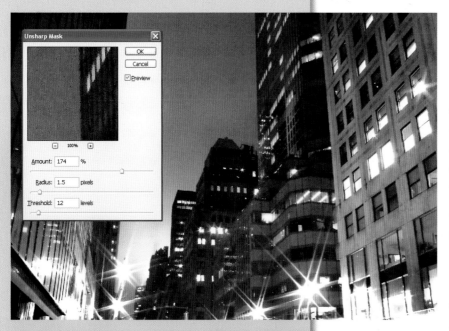

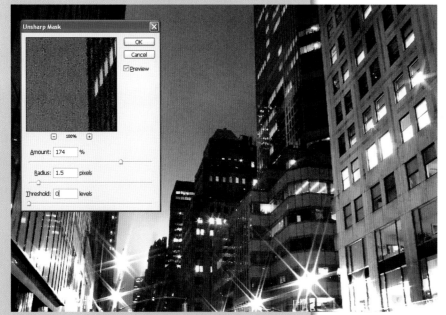

The Threshold setting in Unsharp Mask strongly affects the appearance of noise in a photo. For an image with little or no noise, a lower Threshold setting might be appropriate. If the image has obvious noise problems, setting the Threshold as high as the 10 - 12 level can help to minimize the sharpening effect.

situations, though more expensive cameras typically perform better under these conditions. In addition, smaller sensors generate noise because of their size, particularly at higher ISO settings. There has been a lot of technological development in this area, resulting in today's sensors using much lower ISO settings, regardless of how the ISO is set on the camera.

✱ **Solution:** Use noise reduction techniques for long exposures and experiment with different exposures and ISO settings. Do some tests to figure out the limitations of your camera in regards to noise performance at different exposures and ISO settings.

ISO Setting

✱ Higher ISO settings on a digital camera have more noise than lower speed settings (e.g., ISO 400 compared to 100). This is also true with film—higher speed films have more grain than slower speed films. In both cases, newer technologies have resulted in less noise/grain. A sensor today will have less noise (sometimes significantly) compared to a similar sensor of only a couple of years ago, and film today is far less grainy than film of the past.

✱ **Solution:** Use low ISO settings whenever possible. If you must shoot in low light with high ISO settings, consider getting a new camera with the latest sensor technology.

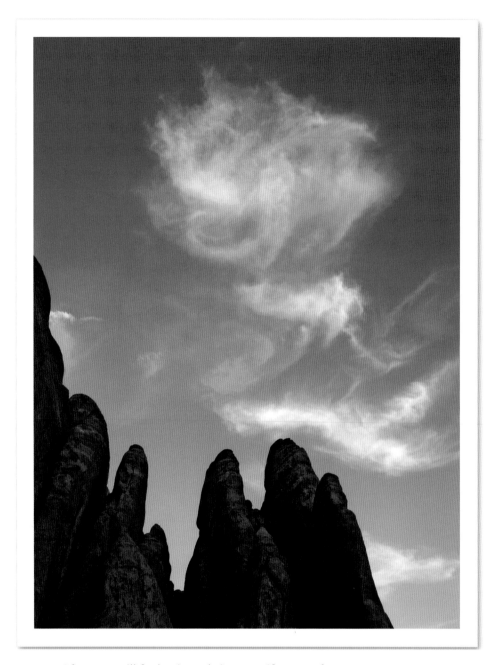

Often you will find noise only in a specific area of an image, such as the dark rocks shown here. You can sometimes remove that noise by making the dark areas darker, for example. It creates a more dramatic composition and takes care of the potential noise problem.

Exposure

✳ Digital camera sensors don't like underexposure and will show more noise in such images. Even the best sensors will create images that reveal more noise if underexposed.

✳ **Solution:** Make sure the exposure is correct. This is especially critical in low light situations and when shooting light, highly reflective, or backlit subjects. Adjust your exposure or use a flash, if needed.

JPEG Artifacts

✳ Too much compression when saving to a JPEG file, or repeatedly opening and re-saving a JPEG image can create little blocky details that look like chunky grain. This is most apparent in same-colored areas with slight gradients of tone such as the sky.

✳ **Solution:** Use JPEG compression sparingly and don't use it as a working format in your image-processing program. Set your camera to its highest quality compression when using JPEG, even though that means larger file sizes.

Digital Artifacts

✳ Sky can be a problem for digital cameras, especially lower-priced cameras or those with fewer pixels. The tone of the sky varies in a subtle gradient starting at the horizon. A sensor must make sense of that gradient, yet it can only deal with bits of it at a time (via pixels). This can cause a grain-like pattern in the sky.

✳ **Solution:** Realize that subtle gradients may emphasize grain. When sharpening the photo, avoid sharpening plain sky areas.

Out-of-Focus Areas

✳ Out-of-focus areas tend to emphasize grain or noise in an image.

✳ **Solution:** Remember that out-of-focus areas and large expanses of one tone emphasize grain and sharpen your image accordingly. If necessary, select the sharp areas and separate them from the rest of the photo before sharpening the image. Never sharpen out-of-focus areas. If the noise is bad in these areas, try a noise reduction program for just that specific area. You can use it quite strongly in such cases because you are not trying to deal with sharp areas that can be blurred by noise reduction; use the same techniques as selective sharpening to create selective noise reduction. You can also try blurring these areas in a similar fashion. Again, the blur has no overall effect because you are only using it in specific areas.

you can alter the adjustments used if they create an increase in noise.

Image-Processing Software

✳ Your image-processing software can amplify the appearance of grain or noise. Hue/Saturation, especially, can dramatically bring out undesirable grain/noise effects in the sky.

✳ **Solution:** Avoid over processing the image and watch for noise as you make adjustments. Sometimes,

Sharpening

✳ Threshold adjustment, indiscriminate sharpening, and over sharpening can affect noise to the detriment of a photo.

✳ **Solution:** Use the threshold control. Avoid over sharpening the photo. Sharpen only the parts of your photo that are crisply focused.

Paper selection strongly affects the final presentation of a photo, and choosing from the many different types available is often a personal preference.

CHAPTER 8

Paper

Ink jet printers are capable of some of the finest photo printing possible. The image quality is so good and has impressed marketing people so much that they commonly hype a printer as being capable of superb results on any paper. But this is simply not true. While you can get a readable image from cheap paper, you will find that quality paper designed specifically for photos will produce the best quality prints.

Paper choice is a really important part of printing, yet it is also an intensely personal choice. It is not about getting some arbitrary "best" paper. A given paper is only best for a certain purpose if it fits the needs and personality of the photographer.

Epson makes a wide variety of papers. Their papers are used by the majority of working professionals and are an excellent place to start with paper selection. This large selection of papers can be confusing, but it is also a wonderful thing for photographers—we can choose the paper that is best suited to meet our exact needs.

There are a number of factors that go into choosing the right paper. In the end, it is a highly personal choice (I may love matte papers, but you may think glossy is the only way to go). I have printed on all sorts of surfaces just to see what I like and dislike. Experimenting with various styles is the best way to gain experience with papers. For example, I don't like canvas papers, but you might. It is a good idea to buy small packages of paper or sampler packs to help you become familiar with the many choices.

Determining the paper styles you like will enable you to make prints that are a real joy to produce.

While lots of papers are "available," you might not be able to find them at any given store. Check office supply and photo stores as well as the Web. You can also buy Epson papers off of their website, if needed. When looking for papers, don't be overly influenced by well-meaning but uninformed sales people at retail locations. I have actually had someone at a store tell me that paper I was looking for had been discontinued—this would have been a big surprise to the manufacturer. They just didn't have the paper and didn't really understand the paper market.

Paper Weight and Thickness

Every paper has a weight and a thickness. These are "technical" terms of a sort, as well as a subjective impression of the paper. They affect how a paper can be used as well as the feeling you get while viewing the photograph. A paper's weight and thickness actually have a psychological impact on the viewer. A few years ago, photo papers ranged from very thin to moderately thick. The thin papers (really more like stiff plastic film) were never

RC Base
Thickness: 10 mil
Weight: 250 g/m²
Opacity: 97%

50 SHEETS
8.5" x 11"
44 lb • 9 mil

really popular with the public because, even though they made good prints, they never "felt" right. They did not feel like the photographic print people were used to from a photo lab. You can't find much like them anymore. Another change is in the thick papers. Many printers can now handle much thicker papers then earlier models. Special openings built into the backs of many modern printers have made this possible.

Photo Papers are measured in GSM (grams per square meter), and almost all photo manufacturers provide specs in GSM. Thicker papers will usually weigh more, so the weight will usually give you an idea of how a paper will feel, though this can sometimes be misleading. You may run across a few papers that are full of air; they can be lighter in weight while still maintaining thickness. In this case, you have to look at the paper's thickness rating.

The bottom line for the photographer depends on what they expect from a print. A heavier weight paper is necessary if the print will be handled, such as passing around to friends and family. Brochures or flyers also need some weight or they will leave a poor impression on their recipients. But, if the print is going to be mounted behind glass, weight may be less important.

Opacity

Opacity is better understood if you think of its opposite, or its transparency. This is determined by how easily you can see through the paper. If it is hard to see through the paper, it has a high opacity. If you can easily see through it, the paper has a low opacity. True photo papers are typically very opaque. The thickness and weight of a paper have a strong effect on its opacity. Opacity is measured in a percentage, with 0% being fully transparent (no opacity) and 100% being fully opaque.

Epson makes a large range of papers to fit the diverse needs of photographers.

Opacity is especially important if you need to put papers together (as in a booklet) or if you need to print on both sides of the paper (as in a brochure). With low opacity, you can see words or photos coming through the image from the flip side of the paper. High opacity makes the photo stand out on the page, regardless of what is on its reverse side.

Surface

Ink jet paper's surface is coated or prepared to accept the ink and produce great prints. Printing photographs on inexpensive, uncoated paper can cause the ink to run and "bleed," resulting in blurry, unsatisfactory prints. Just any coated paper won't necessarily do, either. Occasionally you will find a paper that does not match up with Epson ink jet technology—the ink does not sit properly on the coating, resulting in unacceptable printing results.

Surface also affects how dye-based and pigment-based inks can be used. In general, the really glossy papers are best suited for dye-based inks. Many of the watercolor papers work best with pigment-based inks.

The available surface textures of ink jet papers run from glossy (very shiny) to matte (non-reflective), with in-between variations such as semigloss and luster. Choosing the right surface is a highly subjective process. Different papers can create very different impressions of a photograph when the image is printed. Photographers will actually get into subjective

Paper choice involves looking at paper color (top), the weight of the paper (middle), and the paper surface, such as glossy or matte (bottom).

arguments over which surface is "best," when in fact the "best" one is truly in the eyes of the beholder.

Many photographers like glossy paper because their images look very sharp, colors appear brilliant, and the prints look like traditional glossy photographs. However, not everyone likes a reflective surface or, if they do, not necessarily for every subject. Papers with a matte or luster finish are often preferred for photos of people, for example. I am one who really doesn't care for glossy papers. My preference is a luster or semi-gloss paper, but that doesn't mean you should use that surface type. Paper surface is largely a personal preference. You have to try different paper surfaces to see what you like and which best fits your needs. High-quality papers will give excellent color, sharpness, and brilliance in any surface finish. Papers like Epson Watercolor Radiant White have a matte finish and produce rich tonalities that give prints a "fine-art" quality.

Your end use also can affect your paper choice. Glossy papers do not fold well, so if you need to make a brochure or a greeting card, either use a matte paper or buy specially made papers that are scored to fold easily. In addition, glossy papers almost always have a shorter life than matte papers. But the life span varies somewhat depending on the inks used, the specific paper, and how the print is stored.

Whiteness

Papers are rated for whiteness (or ISO brightness). Higher numbers mean whiter papers. For general-purpose printing, most photographers want as white a paper as possible (rated in the 90s or higher). On these papers, colors are at their brightest and tonalities their richest.

However, some of the appeal in many specialty papers, such as watercolor paper, comes from a certain warmth in the prints made with them. Obviously, in that case, whiteness is not a critical factor in paper choice.

Life

All papers age. They may yellow and deteriorate from exposure to light and certain gases in the air (including pollution). Cheap papers may have acids in them that can degrade the paper itself (and therefore the image) after a few years. Better papers minimize this problem, varying from acid-free to plastic-coated styles.

The inks that are used also affect a photo's life. Dye-based inks generally do not last as long as pigments. Though both types of ink, produced by Epson, now have long lives. Pigment-based inks, when combined with cotton-fiber papers, yield the longest lightfastness. But pigment-based inks work great with microporous papers as well. The lightfastness rating might be 90

years with microporous papers instead of 150 years for cotton-fiber. Even 90 years is pretty good when you consider that the average Kodak C print is predicted to last only 26 years before noticeable fading occurs.

Use

As hinted at above, how you plan to use your prints will affect your paper choice. Will people be handling your prints? Choose a heavier paper. Do you plan to make brochures? Be sure the paper folds properly. Do you need to print on both sides? Be sure your paper is coated for two-sided printing (most are not). Do you want to sell prints? Consider the feel, look, and longevity of the image on the paper.

Watercolor and Fine-Art Papers

The availability of matte-finish, high-quality papers with a watercolor or fine-art paper look and feel has become very important for many photographers. These papers now offer superb results, very long life, and add a certain richness and depth to the image. Epson's fine-art papers are 100% cotton-fiber, acid-free papers available in several surface textures. Plus, there are quite a few excellent specialty papers made by independent companies that are worth checking out.

Specialty Media

Specialty papers and printing media offer unique solutions to your photo needs that regular papers can't provide. You may want to explore the specialty papers that are available and discover what they can do for your photography.

Dan Steinhardt

Paper surface is a very subjective choice for a photographer; some prefer a strong gloss surface and others prefer mattes and lusters.

Rolls and Sheets

Rolls and large sheets of paper are great for printers designed to handle them. A number of Epson printers offer roll-paper handling capabilities, which make it easy to print multiple prints without having to deal with single sheets of paper. Roll-paper can also be used to create long panoramic images. Some Epson printers even include an automatic print cutter that will allow you to leave your printer unattended while it prints and cuts your photos.

The combination of borderless printing and paper rolls makes it quite easy to produce multiple 4 x 6 inch prints like the ones you can get from a mini-lab. The difference is that the printing is under your control. The printer pulls the roll paper in as needed and you get a long strip of borderless prints that are easy to cut to their final size (or are automatically cut with the right printer).

Rolls are really helpful with panoramic image printing. "Panos," as people often call them, can vary considerably in their height (top-to-bottom) to width ratio. Epson Stylus Photo printers can continuously print an image with the full width of the printer's paper path up to 44 inches (111.8 cm) long (some of the really big printers can do even longer).

For example, you can find specialty printing media that enables you to use your images in unique ways. These include iron-on transfer paper to put a photo on a T-shirt, photo stickers, scrapbook media, and more. Some of the really specialized "papers," such as metallic, silk, and transparency material can be hard to find anywhere except on the Web. If you experiment with the range of printable paper possibilities you will enhance your photographic prints.

Paper Manufacturers

Epson makes a diverse line of papers. This makes printing easy and consistent because the printer driver (the software that controls the printer) includes settings that are directly linked to the different Epson paper specifications.

Epson wants you to be successful at printing, so its engineers and product development folks want to sell you papers that work really well with their printers.

Epson printers and their drivers are definitely optimized for Epson papers. This should come as no surprise since the company has invested a lot in printer quality and wants consumers to get the best results from the combination of their printers, inks, and papers. Epson has also created paper profiles for its paper products and included them in the printer driver software that comes with the printer to help ensure great results.

However, Epson printers have become such an important part of the photography industry that many

companies have found it profitable to make high-quality papers that are optimized for Epson printers. The papers available on the market change quite often, so it is hard to give specific examples.

I do not recommend any of the inexpensive or economy photo papers. These tend to offer little more than being cheap. I have tried them and found that colors were harder to control, profiles were unavailable, and they didn't have the same feel as better papers. In addition, testing by companies such as Wilhelm Research has shown that the life of images printed on these papers tends to be much shorter than higher-quality papers.

To give you an idea of the range of papers possible, here are some lists of papers available from various companies (the lists give most papers, but are not all-inclusive).

Epson Photo Papers:

Glossy:

Ultra Premium Photo Paper Glossy

Premium Photo Paper Glossy

Photo Paper Glossy

Semigloss:

Premium Photo Paper Semigloss

Semigloss Paper Heavyweight

Posterboard Semigloss

Luster:

Ultra Premium Photo Paper Luster

Premium Luster Photo Paper

Matte:

Premium Semimatte Photo Paper

Enhanced Matte Paper

Ultra Premium Presentation Paper Matte

Enhanced Matte Posterboard

Proofing Papers (to match publication papers)

Proofing Paper Commercial Semimatte

Proofing Paper Publication

Proofing Paper White Semimatte

Fine-Art Papers:

Exhibition Fiber Paper

Watercolor Paper Radiant White Canvas

Epson Velvet Fine Art Paper

Somerset Velvet Fine Art Paper

UltraSmooth Fine Art Paper

Textured Fine Art Paper by Crane

PremierArt Water Resistant Canvas for Epson

Miscellaneous Papers:

Semigloss Scrapbook Photo Paper

PremierArt Matte Scrapbook Photo Paper for Epson

Crane Museo Artist Greeting Cards

Photo Quality Self Adhesive Sheets

Photo Quality Ink Jet Cards

Specialty Media:

Iron-On Transfer Paper

Photo Stickers

Memorex Ink Jet Printable CD-Rs

Epson's Exhibition Fiber Paper

As this book went to press, I learned of Epson's Exhibition Fiber Paper and had a chance to see it. The results truly do look like prints from the old darkroom, especially in black and white. I know that Epson put a lot of work into this paper to get that look, and it shows. This is not a surface everyone will like, but it does offer some outstanding features, including extreme blacks and detail in the dark tones, a wider gamut of colors, and a heavy photo paper-like feel. It is only available for the K3 ink printers and is a fine-art paper best used loaded one sheet at a time.

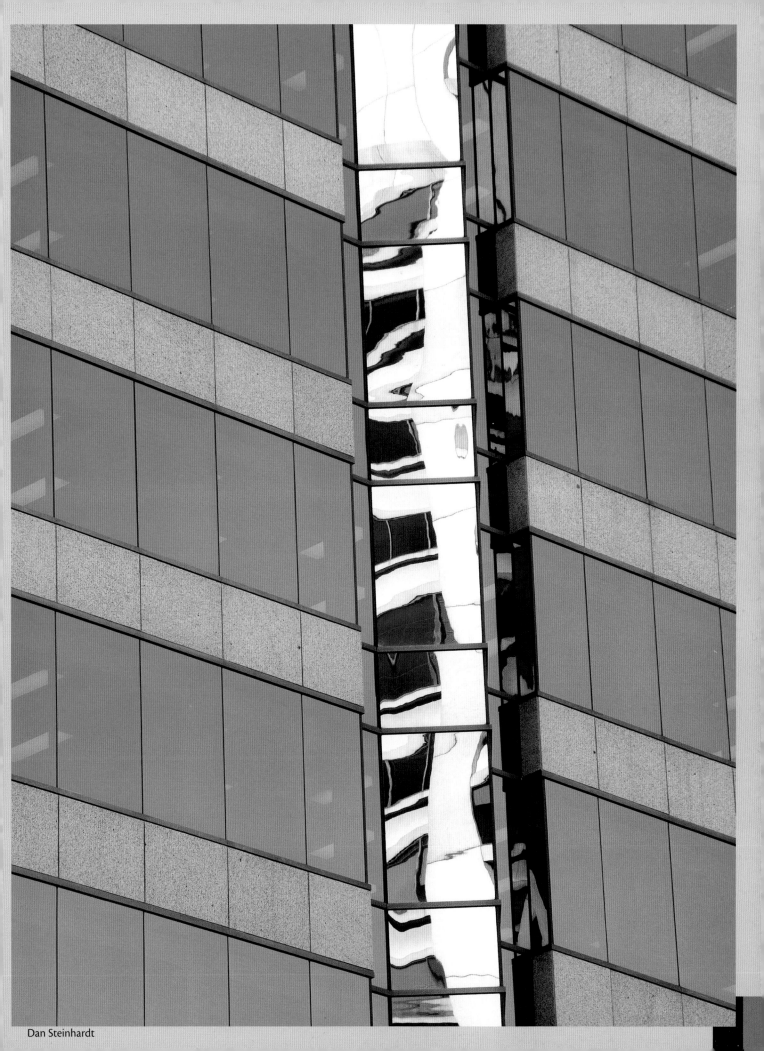

Dan Steinhardt

CATHERINE HALL

SUPERB IMAGE QUALITY FOR CLIENTS

Catherine Hall has become a celebrated wedding photographer, but has also traveled the world shooting subjects as varied as tribal cultures and corporate events. She began to photograph when she was only sixteen years old, and has loved taking pictures ever since. This love has gained her recognition all over the world; her images have appeared in Times Square, National Geographic Traveler, American Photo, The New York Times, and many other well-known publications. She shares her love of photography

with others through teaching at workshops and presenting at photography tradeshows.

Hall realized she wanted to be a wedding photographer after taking a picture of a flower girl staring at her bouquet—she discovered a real love for this type of quiet, intimate image. As a boutique-style wedding photographer, she aims to deliver the highest quality product possible with a devoted attention to detail. Ink jet printing has helped her open many doors since it gives her complete control to be a printmaker as well as an artist. "For the first time in my life I feel like I can clearly illustrate my vision without compromise," she says. And for any pho-

tographer, that is the ultimate goal.

Hall, a high-end wedding photographer, uses the Epson Stylus Pro 3800 printer to fill orders and make gifts for clients, but she also creates prints for exhibition, competition, décor in her studio and office, and marketing and promo-

a point where ink jet prints truly surpass the image quality attainable in the dark room." She loves the control it gives her so to achieve "beautiful skin tones, neutral black and whites, unmatched tonal range, and extraordinary color saturation." She relishes the fact that her prints will be cherished for generations to come.

tional materials. Most of these prints are made on 13 x 19 inch (33 x 48.3 cm) and 17 x 22 inch (43.2 x 55.9 cm) paper. Hall also prefers to print her images on Ultra Smooth Fine Art Paper and Velvet Fine Art Paper.

Inspired by the overall quality and control ink jet printing can give her, she notes, "We are finally at

Hall's advice for photographers is to, "create custom color profiles for monitors and printers. I use the X-rite system. Then take advantage of the vast range of available ink jet products. Experiment with Epson's fine art papers and using both matte and photo black ink." Lastly Catherine suggests, "Embrace the technology of this incredible medium."

Hall's website is www.catherinehall.com.

Ink jet prints—with proper care and handling—have the potential to last many years.

CHAPTER 9

Print Longevity

If you are a recent convert to digital printing, you may find it hard to believe that when ink jet printers first started producing true photo-quality prints, they faded very quickly. There were no pigment-based inks and no long-lived dyes. With some of the earliest photo-quality printers, a print could fade in as little as six months. It didn't take long for ink jet printers to rival the quality of traditional prints in color and tone, but longevity was still a serious issue.

Today, most quality photo printers on the market offer a decent lifespan for their prints. All of the major printer manufacturers now have long-lived pigment-based inks. In addition, Epson offers long-lived dye-based inks.

The life of a print remains an important issue for photographers. They want to be able to display photos for longer than a few years. They also want to be able to give away or sell prints that can be enjoyed for generations.

Photographers have long aspired to the lasting print life exhibited in black-and-white silver based photography. When properly processed, black-and-white prints have lasted since the 1800s. They had great resistance to fading. Early color prints from the 1950s and 1960s did not fare so well, and often faded within a few years. This was improved and by

the late 20th century the lifespan of color prints had reached decades. But now, some ink jet prints surpass even the longevity potential of black-and-white photography.

Epson was the first manufacturer to focus on longevity as a key characteristic for a photo print. They were the first company to come out with dye-based inks that would last as long as traditional photo prints, when used with the appropriate papers. This was a major breakthrough in ink jet printing technology.

Epson was also the first to figure out how to use colorful pigment-based inks in an ink jet printer without clogging the heads—a problem originally encountered with this type of ink. These first pigment-based inks were independently tested and rated to last for over 100 years. While the first pigment inks weren't quite

up to the colors of dye-based inks, they were still quite good.

Today, Epson continues to be a leader in the printing market, offering brilliantly colored ink sets with very long lives. The company was the first to really recognize and support photographers who had started making digital prints with ink jet printers. This made them a forerunner in the field, and in spite of excellent strides made by competitors with their inks, Epson continues to hold the lead. They continuously develop better inks and manage to squeeze even more quality out of a photo print.

But ink isn't the only thing that affects long life, especially when you look at the archival qualities of a really long-lived print.

Print Permanence

Loosely defined, print permanence refers to the longevity of a print. This describes how long a print will look its best without noticeable fading or color shifts over a period of time. Debate still exists over exactly how long this period of time must be and what is considered to be noticeable fading or color change. Light has the greatest influence on print life, but storage conditions, storage materials, heat, and humidity also have an effect.

The major printer manufacturers have elected to use similar, fairly conservative testing standards for their prints, enabling them to state the lifespan of their prints with confidence. But, there have been paper

manufacturers and distributors who have used different, less stringent standards for testing the permanence of prints. At any rate, how long a print lasts is always dependent on both the ink and the paper being used. Neither exists apart from the other.

A very interesting aside to this topic is that digital prints may be the best way to ensure that a digital image will last for a long time. There currently is a lot of debate surrounding the storage of photographs in digitized form as computer files. Will they be able to be opened in the future? What storage media will both last and be usable many years from now? Quality prints, stored in special, archival boxes that block out light will last a very long time and have no future accessibility issues. Plus, the print could always be scanned or

2010

2060

3010

Print permanence means that a photo printed now will essentially look the same over a long stretch of time.

photographed to turn it back into a digital image. While this will not give the absolute best possible quality compared to using the original image file, it is a simple and sure way of archiving important photos.

Testing the permanence of inks and papers is currently done by exposing prints to high-intensity light,

which simulates light exposure over many years. Epson endorses the standard practice of testing fading by simulating exposure of a print over time to at least 450 lux (a very bright indoor light) for 10 – 12 hours a day.

Henry Wilhelm, considered by many to be the expert in permanence research, does this type of testing. His website (www.wilhelm-research.com) supplies important information about how different inks and papers last over time. If print longevity is important to you, check out his latest findings.

However, there is no absolute standard for testing, and some companies do not follow the general practices of the industry. Some manufacturers have asked for an ISO standard (an international standard from the International Organization of Standards) that could be applied across all print longevity testing. But so far, this has not happened.

Print permanence is affected by more than just the ink and paper. There are a number of factors that work together to affect print life:

Print longevity is tested using intense light on a print over a period of time and measuring the visual change.

NOTE... Severe conditions, such as prints under direct sunlight, shorten the life span more than the results shown by these tests.

ink, paper, light, pollution (especially ozone), temperature, and humidity. How a print is stored or displayed will affect what the print is exposed to, and can alter its lifespan.

Ink and Paper

Epson uses two basic types of inks: dye-based and pigmented. Prints made with Epson pigment-based UltraChrome High-Gloss and K3 inks resist fading longer than a print created with any dye-based inks. However, Epson's new dye-based Claria inks are a real

breakthrough for ink technology and will retain their colors for decades.

With Epson's Claria dye-based photo inks, you can expect a print to resist fading (the Lightfast rating) for over 90 years when the print is displayed behind glass. If you put one of these prints into "dark storage" (in a protected, archival box without light) for true archival purposes, you can expect a lifespan of over 200 years. These numbers are way past the range of life for traditional color prints from the local mini-lab.

With Epson's UltraChrome K3 inks, print life is highly dependent on the paper used. Traditionally, glossy papers had relatively short lives with most inks. But now, you can expect a 60 to 70 year life with glossy, luster, and semi-matte papers when displayed under glass. With Epson UltraSmooth Fine Art Paper, prints will last well over 100 years when displayed under glass. If they

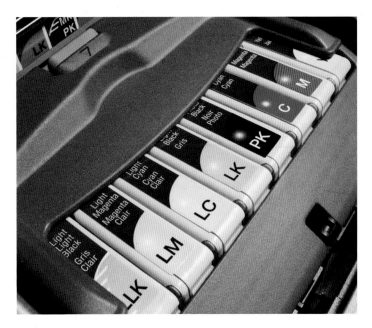

Ink type has a big effect on print longevity. Pigment-based inks tend to last longer than other inks on the market today.

are placed in dark storage, these prints will easily last 200 to 300 years. That is a long time! Longer than any traditional photographic printing process to date.

Image Storage

The better the conditions in which a print is stored, the longer its life will be. Durability of the print itself is an important issue. Traditionally, dye-based prints could withstand handling better than those created with pigmented inks, because the ink is actually absorbed into the paper. All prints with pigmented ink surfaces are more easily scratched and damaged than dye-based prints. Early pigment prints were very sensitive to abrasion. Epson has put a lot of research into this challenge and today's UltraChrome inks have a much-improved scratch resistance.

You can expect a very long life from a print if it is kept out of the light in a protected album or other storage system. To make sure that the actual storage method does not interact with and degrade the print, it should be made of archival materials (such as acid-free paper).

A print that is on display should be framed and kept behind glass to maintain its longest life. Be sure the

You can take steps to lengthen the life of your print by mounting it behind glass or storing it in a protected environment.

framing materials, such as the matte and mounting boards, are archival quality (acid-free). And remember, exposure to bright sunlight or fluorescent lights will shorten the print's life.

Putting an image behind glass minimizes problems with pollution and can reduce the amount of ultraviolet light the print is exposed to (which can fade prints). However, it is important that an Epson print is not put behind glass immediately after the print is made. Even though Epson prints feel dry to the touch and are highly resistant to water damage, they are not completely dry for hours after the print is made. You should avoid placing a print behind glass for at least 24 hours.

Photos on display have to deal with whatever conditions are present in the display area. Moderate temperatures, low humidity, and moderate light levels (no direct sun) are ideal conditions to help prints last the longest. While these conditions aren't always possible, I would never keep a print off display just because the conditions weren't ideal for a long life. A print should be seen and proudly displayed! If that image needs to have the longest, most archival life possible, then print two images—one for display and one for archival storage. Store the second print in a dark, archival box in an area where the temperature and humidity are kept at moderate levels. That way you have one print for display and one stored to sustain the longest life possible.

Fine black-and-white prints are now possible with ink jet printers.

CHAPTER 10

Black-and-White and Panoramic Prints

Black-and-white photography seemed to almost disappear when color film dominated the market about 15 years ago. Color was what sold and it became the norm in magazines and other publications. Many photographers who once had darkrooms abandoned them.

In recent years, however, black and white has gained new attention and appreciation. Many photographers and those who enjoy creative photography have rediscovered that black and white gives a fine-art touch to images, while the color print appears more familiar and commonplace. Epson responded to this interest by developing new algorithms and inks, which make black-and-white printing with an Epson ink jet printer better and easier.

Wide-framed panoramic photos have long been popular with traditional photographers. They used to make multiple pictures of a scene, then line up and paste the prints together to create a makeshift panoramic. True panoramic images were hard to get made into large prints, and the specialized cameras needed for quality pans were expensive and scarce. The computer changed this dramatically. Digital has also fostered a new interest in panoramic photography. Epson has long been a leader in panoramic printing—even their early photo printers were capable of producing the long, narrow panoramic format. Today, everyone can produce panoramic images and print them with an Epson printer.

Black-and-White Printing

Photography got its start with black-and-white outdoor images, and the tradition of black-and-white landscape work is especially rich. It includes the Western frontier photography of Timothy O'Sullivan and William Henry Jackson, through the grandeur of Ansel Adams, to John Sexton's

glowing black and whites of today. It was actually the black-and-white prints of Jackson that, over one hundred years ago, helped influence Congress to set aside Yellowstone as the first national park.

A fine black-and-white print can be a pleasure to view—often it's far superior to anything you will see printed in a book or magazine. Yet, getting a good black-and-white print hasn't always been easy. The local mini-lab rarely will give you top black-and-white results and building a darkroom isn't practical for most people today.

However, ink jet printers are capable of producing superb black-and-white images. In addition, the computer lets us do things to a black-and-white image with more control and precision than you could ever do in

the traditional darkroom. Both of these aspects of digital photography have greatly contributed to the rebirth of interest in black-and-white photography.

Getting to Black and White

Traditionally, black-and-white photography was shot with black-and-white film. This is still a viable and challenging way to photograph, but most photographers have gone to digital today.

Today, you have two excellent ways of going black and white when you have a digital camera. Many cameras allow you to shoot black and white directly. These cameras produce the image file without color, so you can see the black-and-white effect on your LCD monitor. Also,

then convert to black and white. This method adds some unique advantages that are unavailable when the original image is captured in black and white. These are related to filter effects, and how different colored filters change the tonality of a scene as it is captured from real-world color to black and white.

Shooting Black and White

There are advantages and disadvantages to both approaches. Here's why you might want to shoot black and white in the digital camera:

1. You see what you get. Observing how a scene translates to black and white will influence how you photograph it. Good black-and-white images are not simply a color scene without color. There is an art to recognizing and capturing black-and-white tonalities in a scene. If you have not shot a lot of black and white, there are big advantages to shooting in-camera because you can review and revise your results based on what is in the LCD.

Visualizing black and white in a color scene is a learned skill, but cameras with black-and-white settings allow you to compare the scene to the black-and-white version on the LCD monitor.

you can often adjust the camera so it gives "filtered" effects to better define black-and-white tonalities.

Many photographers are also discovering that the computer provides a new option—shoot in color,

2. The experience is more direct. When you shoot in-camera black and white, you begin to work in a creative space that is not the same as shooting in color. You see things differently and work the scene in new ways. This can be a disciplined and connected way to shoot black and white. It definitely provides a different creative challenge and experience.

3. You can adjust filtration effects to fit the scene while you are there. By using the camera's built-in filtration effects or camera filters made for black-and-white shooting, you can immediately see how certain colors in the scene are rendered as gray tones. This allows you to respond and adjust to achieve the best creative interpretation while still at the scene. This is also a great way to learn about filtration.

4. The image is close to finished. When you shoot in black and white you don't have to do conversion from color. You still need to do some work on the image based on blacks, whites, and midtones, but your work is shortened. On the other hand, this is a disadvantage because the tonalities are locked in and you cannot change the color-to-tone interpretation.

5. RAW with black and white gives you flexibility. When the camera is set to shoot black and white, you are creating black-and-white JPEG files. RAW files are not converted to black and white. In fact, if you process the photo in any RAW converter other than the camera manufacturer's program, you won't see the black-and-white image at all. The camera does include black-and-white processing information attached to the RAW file's metadata, but few RAW converters other than the manufacturer's recognize it. An interesting option when shooting black and white is

to shoot RAW plus JPEG (if your camera offers this option) so you get the best of both formats.

Converting to Black and White

The other choice is to shoot color and convert to black and white in the computer. This also offers a different set of advantages:

1. You have created a full-color file and are not locked into just a black-and-white image. A big disadvantage of shooting black and white directly is that it can't be changed to color or any other black-and-white tonal interpretation of the scene. You are stuck with that one file. Shooting in color keeps the options open, but it does mean you need to understand how color changes into black and white.

2. Filtration after the fact. Filters strongly affect contrast in black-and-white photography. Dramatic skies are created using red filters, bright foliage is enhanced with green filters, and so on. You can always filter the color image in the computer after shooting to translate the scene into these preferred black-and-white tones, or different renditions to create many moods.

3. Interactive filtration. Suppose you are new to black-and-white photography and don't totally understand filters and their effects. With the digital darkroom, you can try different filter effects on the same scene and instantly see how they change it.

4. Totally variable filtration. No matter how many filters you take with you into the field, you still have a limited set of filter colors to use to control the tones of the scene. In the computer, you can fine-tune the filter colors to very subtly adjust grays in the black-and-white image.

5. Multiple, selective filtration. Think of a scene with red flowers against green foliage in a landscape that includes beautiful clouds in a blue sky. A red filter will make the sky darkly dramatic, setting off the clouds, but maybe you don't like its effect on the plants because the red flowers will be light against dark foliage. You could use a green filter to make the leaves light and the flowers dark, but the sky will not be so dramatic. In the computer, you can select the flowers and foliage part of the photo and apply a green filter, then select the sky and apply a red filter effect.

Translating Color into Black and White

You can easily translate color images into black and white in the digital darkroom with an image-processing program and an Epson printer. Translate is exactly the right word, too. You need to be able to make the shades of gray relate well to the original colors. Just as translations in language can be good or bad, so can black-and-white translations.

In general, I don't recommend using the straightforward grayscale or desaturate commands. Grayscale discards all color

information and Desaturate gives a black-and-white image in a color space. These are quick and easy ways of dealing with images that don't need a lot of adjustment, but with many photos, they tend to make the image look too gray without enough contrast.

Here are a number of good ways of making the color translation to black-and-white tones:

Figure 1: Photoshop CS3. If you are interested in black and white, the new black-and-white command may be worth the entire cost of upgrading to the

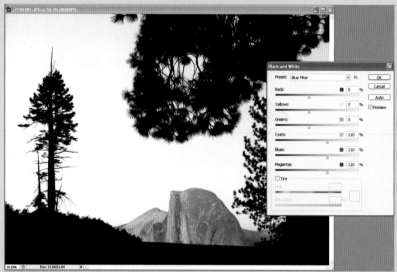

Photoshop CS3's black-and-white conversion tool allows you to click and drag changes on the image.

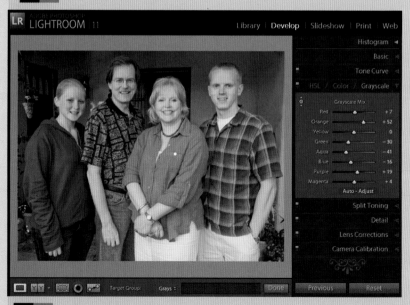

Lightroom's grayscale settings offer an excellent set of color adjustments for black-and-white conversion.

program—the command is that good! Before CS3, black-and-white conversion in Photoshop was a bit geeky and the controls involved could be a little awkward and not very intuitive. The new control is under Image>Adjustments>Black & White, but I recommend you do this as a layer for more control. This new control includes many presets that automatically perform a whole range of translations. But the really neat part of this is the ability to go right to the photograph and adjust there. You move the cursor onto the image, click

on something, and Photoshop automatically finds the right color to adjust to a gray. Then you move the cursor right or left to make that tone lighter or darker. This is very photographic and a lot less computerish.

Figure 2: Lightroom. This uses a control that is similar to the new Photoshop Black & White adjustment in its Develop module. In the Grayscale adjustment, you click on a small button to the top left of the Grayscale Mix slider panel to activate the cursor. You click on the photo, Lightroom finds the right color to translate, and you make it lighter or darker by dragging the cursor up and down.

Figure 3: Nik Color Efex. This Photoshop-type plug-in offers a superb black-and-white conversion tool (most programs, not just Photoshop, can use Photoshop-type plug-ins). It is available in the Color Efex Pro complete collection as well as lower-priced bundles of effects (www.niksoftware.com). What makes this little program so effective is that you control the filtration of the scene with a simple slider that goes across a spectrum of colors. As you adjust the slider, you can watch how the filter colors affect the gray tones in the image. It is like having an infinite set of color filters for black and white. In addition, you can control the strength and brightness of the effect as well.

Figure 4: Color channels. Photoshop and other advanced programs include the ability to look at and separate the individual color channels that make up an image (these are usually RGB—red, green, and blue). In effect, this gives you three very different conversions to black and white, as if you shot the scene separately with red, green, and blue filters. This is a very simple way of seeing several translations. Once you find a color channel that looks good to you, you can delete the others or change the photo into a grayscale image, which gets rid of all color information. The Split Channels command will separate the color photo into three separate black-and-white images based on the channels.

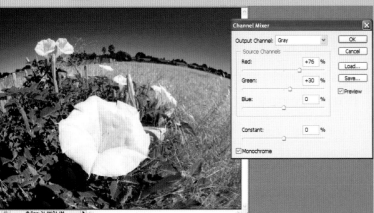

Nik Color Efex software has several intuitive black-and-white conversion tools.

A traditional Photoshop black-and-white conversion is through the Channel Mixer dialog and the Monochrome setting.

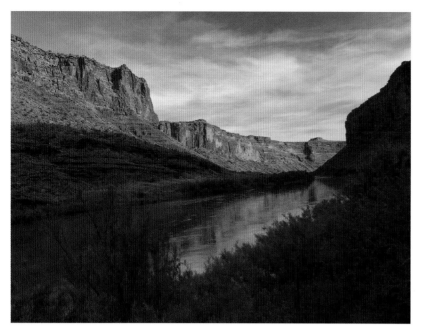

part of the scene with one color filter and another part of the scene with an entirely different filter. That is impossible to do when shooting directly to black and white.

✳ **Grayscale vs. RGB color for black and white.** A grayscale image is a photo without color except black, white, and gray. It is a smaller file than a color image. All of the above techniques can be converted to Grayscale if needed. Having a black-and-white photo in RGB color, however, allows you to color or tone the image with a color toner effect such as sepia or cool selenium tone.

✳ **Channel mixer.** Photoshop has an interesting tool in the Image/Adjust menu and in Adjustment Layers called the Channel Mixer. This was the best way of translating colors to black and white in Photoshop before CS2. If you open this and set it to black and white, you can adjust the tonalities of the black-and-white conversion by playing with the red, green, and blue channel sliders. More of any channel will make colors related to that channel lighter, and opposite colors on the color wheel darker (e.g., more red will make reds lighter and blues darker). If the numbers for each channel add up to 100, the photo stays at about the same brightness as the original color image. If they go higher, the black-and-white version gets lighter; if lower, it gets darker.

✳ **Selections.** Using selections (or layer masks) can really set your black-and-white adjustments apart. This gives you control that is impossible to have when shooting black and white in-camera. What you can do is select parts of the image and apply the black-and-white conversions selectively. For example, you could use one translation on the bottom of the photo that had flowers and grass and something completely different for the sky and clouds. This then allows you to selectively change colors to gray tones, as if you shot

Adjusting the Black-and-White Image

Once you have a black-and-white image, you will usually continue to make adjustments in your image-processing program. If you did not do the basic Blacks, Whites, and Midtones adjustments, you can do them now. Try increasing the contrast to make the photo more dramatic. With Levels, bring the left (black) slider to the right and move the other sliders left to increase contrast. With Curves, make the line steeper for more contrast.

You can also dodge (lighten) and burn (darken) parts of the photo as well as darken all the edges, clone, and so forth, just as you would with any photo.

Epson's Advanced Black-and-White Photo Mode

Epson includes an interesting advanced setting in the printer driver for the pro printers that is specifically designed to help make better black-and-white prints—the Advanced B&W Photo mode. This was developed with the help of leading creative professionals and is directly geared toward the needs of black-and-white photographers.

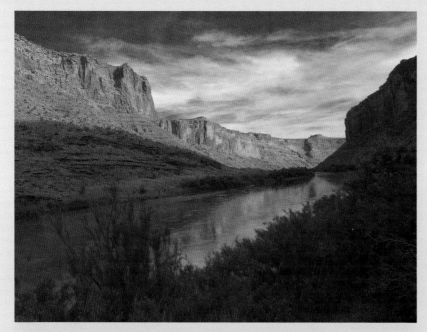

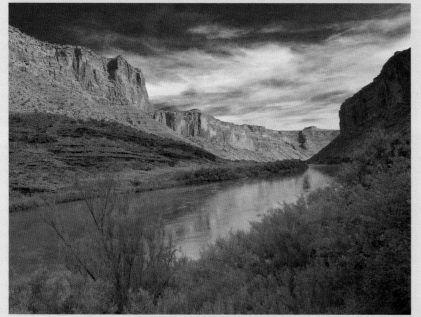

the longevity of the print.

Advanced B&W Photo settings only work with the higher printer resolutions and specific papers. If you select a resolution or paper that is not compatible with these settings, the Advanced B&W Photo mode button will be grayed out.

Toning the Photo

Adding a slight color tone to an image will give it more depth when printed. This is a big advantage with Epson's Advanced Black-and-White mode. Toning can improve a black-and-white print from any printer, especially with printers that don't have three "blacks" or black plus dark and lighter grays. Typically you will have trouble getting a pure black-and-white print with such printers. Rather than drive yourself crazy trying, you can simply use color to your advantage to create a color-toned image that has a distinct and attractive underlying color similar to traditional sepia or selenium toners.

If Ansel Adams could do it, why can't you and I? In fact, all of the major black-and-white printers toned their photos. If you go to an exhibit of Adams' work or perhaps Paul Strand's, you will see most images have at least some color toning applied to them.

The easiest way to do this is to start with your black-and-white image in the RGB color space. You then use several techniques to add color:

✳ **Color Balance.** Adjust the color balance to add yellow and red for warm sepia tones, or cyan and blue for cool selenium tones. Experiment with the amount of adjustment as you make prints, then once you have a good print, record the adjustments for future printing.

It is a bit of a departure from the standard use of profiles with pro printers, since this involves adjusting the printer's output at the printer driver level and not with profiles. The settings in the advanced black-and-white mode offer a number of controls for the photographer such as adjusting the image's color or tone (which can range from making the print warmer or cooler), brightness, contrast, shadow, tonality, and density. All of these changes are made without affecting the original image and you can save specific settings to use again. In addition, Advanced B&W Photo mode sets up the printer to use only the necessary inks, which increases

✳ **Hue/Saturation.** Use the colorize feature and change the hue setting to give you the color you want. Tone it down with the saturation control.

✳ **Color layers.** Add an empty layer over your photo. Fill it with a cool (blue-purple) or warm tone (yellow-orange), then change the layer mode to color. Tone down the effect by reducing the layer opacity (10-15% often works well).

✳ **Photo Filter.** Photoshop includes a Photo Filter adjustment layer that includes a good variety of colored filter effects, which can be used to color an image.

✳ **Duotone effects.** Change your image to grayscale, and then click on Duotone, if your program has it. You now select the type of tonality you want (e.g., duotone, tritone, etc.). You will see several "ink" colors, starting with black. Click on the ink and choose a warm color to go with black for a sepia-tone effect or play around with colors for all sorts of effects. Then vary how each "ink" is used in the photo by clicking on the Curves box and changing the curve. There is a live update as you do this, so play until you get exactly what you like. This control allows you to mix colors in some rather unique ways. Personally, I like the first three effects best because they are more intuitive and easier to use.

Panoramic Photos

The panoramic print has gained a lot of attention over the past few years. A long print showing a wide view of an area gives the viewer a new perspective on a scene. While especially popular among landscape photographers, panoramic images work with many subjects.

Photoshop CS3 made panorama making easier than ever with its advanced alignment algorithms. In

Still, just because you can print a panoramic format image doesn't mean any subject will make a good panoramic print. You must compose and shoot an image that uses the entire subject area effectively. A panoramic image must work across the full print from left to right. Common mistakes are:

✳ Creating an image that has all the interest in the center – if you can crop off the sides without hurting the photo, you won't have a good panoramic print.

addition, ArcSoft PanoramaMaker continues to be a great software value that rivals programs many times its price. It also has encouraged many photographers to try panoramics.

Epson was the first printer company to offer ink jets that could print the long images that panoramic photos required. You can easily print photos up to the full width of the paper and 44 inches long (for standard printers), and with no length limit with Epson's graphics printers. Panoramic images definitely gained in popularity because Epson printers were available to print them.

✳ Making a photo with a lot of stuff from left to right, but nothing really structures or defines the image. A pattern is usually not enough because patterns don't need a panoramic format to work.

✳ Having an unbalanced image where part of the panoramic looks good, but there are distinct gaps in interesting visual material.

Shooting for Panoramics

To make a good panoramic print, you could shoot with a panoramic camera and scan the resulting negative or transparency. It will be too big for most film scanners, so you'll need to use something like a high-resolution flatbed scanner with transparency adapter.

Most photographers today are building panoramics from images shot with a standard digital camera. This has become very easy to do, and while sophisticated tripod heads can make the process work smoother, they are not a necessity.

To do this, shoot a series of photos from one side of the scene to the other, overlapping each shot. Then put them together in the computer. One advantage to this is that you can use the equipment you already have.

Tips for Shooting Panoramics

✳ **Plan out the panoramic.** Figure out what will be included in the composition from left to right (or top to bottom if you are shooting a tall panoramic image, which can be an interesting variation on the technique). To keep a viewer's attention, a panoramic needs to have interesting things happening from one side to another, with no dead space.

This panoramic of Gooseberry Falls State Park in Minnesota was created from five different shots. The camera was leveled, set to manual exposure, and each shot was overlapped.

✽ **Level your tripod and camera.** As you move it across the scene taking photos, the camera needs to follow a horizontal plane or the resulting images will be hard to line up. Do the leveling in two steps: Tripod first (use the bubble level) and then the camera. You can check to see how level the camera is by panning it across the scene—the top should be at the same line from start to finish.

✽ **Shoot a series of photographs across the scene.** Work from the left to the right side of the composition, moving the camera slightly before each shot.

✽ **Overlap the images by 20-50%.** More overlap can make it easier to line up the photos in the computer, especially with automated programs. Look for strong visual elements that are in the overlap areas – they will help to align the images. They will also dictate how much overlap you need.

✽ **Shoot on manual.** Your exposure needs to be optimized and the same through the entire sequence of images or the final pieces of the pan will have tonal variations that will not match up. Also, stay away from auto white balance. Use the same white balance setting or you may get color variations, too.

✳ **Practice.** There is no question that panoramic photography gets easier as you do more of it.

Once you have your shots, bring them into the computer. With a digital camera, this is a relatively straight-forward step, since all the images should be identical in size. Do not crop or change the image size at this point.

Stitching Programs

There are two basic ways of dealing with a panoramic image composed of several individual images. You can use a stitching program that does the work for you, or you can use image-processing software that has layers and you do it yourself. There are advantages and disadvantages to each method. Stitching programs (such as ArcSoft's Panorama Maker (www.arcsoft.com), or the Photomerge option in both Photoshop and Photoshop Elements (www.adobe.com) are very easy, but work best when there are distinct objects in the overlapped areas. In addition, they should have a healthy overlap of the images (30-50%) to do their stitching. Some programs have some "morphing" capabilities that allow the images to blend better when things don't match perfectly.

With a stitching program, the steps are pretty straight-forward. First, you need to check all of your photos to be sure they are consistent in size and tonality. Any big changes in brightness, for example, will show up as unevenness in the final image.

Make any adjustments needed to give them the required consistency before you try to stitch them together and then import them into your stitching program. While some programs claim to be able to figure out the order of your photos automatically, you can usually help the program work more efficiently if you put the pictures in order from left to right (or top to bottom).

Then tell the program to go to work. Depending on the processing speed and RAM of your computer, this will take a little time. RAM is really critical, as panoramic photos can get quite large. Once the processing is complete, take a look at your photo. You may find a section that is a problem due to uneven tones. You may have to go back and adjust that photo, then redo the panoramic. Minor problems can often be corrected with the cloning tool. You'll usually have to crop the final image to fix the edges.

Panoramic Skies

The sky part of a constructed panoramic photo is one place where you will often run into problems. Inconsistencies of tone here can really make an otherwise good panoramic look bad.

Probably the easiest way to fix skies is to use a combination of selections and layers. Let's look at how you would do this to replace an entire sky. This is simplest to do with a small sky area without clouds (these tend to show problems more, anyway).

✳ **Select the sky.** Use the Magic Wand selection tool or other automatic selection tools (such as Color Range). Select the whole sky, even if you have to do it in stages, adding in parts from different layers. You may need to add a very slight feather (just a few pixels) to blend the edge.

✳ **Add a blank layer.** An empty, blank layer on top of your layer stack will receive the sky fix. Having this on a separate layer makes it much easier to control the effect.

✳ **Choose sky colors.** Pick up colors from the original sky if you can. In Photoshop and Photoshop Elements, you can select a foreground and a background color. Double click on the color icon and you will get the Color Picker. Move your cursor over the sky and it will turn to an Eyedropper. If there is any color in the sky at all, click on a dark color for the foreground and a light color for the background, since most skies blend from dark to light as they get close to the horizon. Otherwise, pick good sky colors from the Color Picker palette—again, a light one and a dark one.

✳ **Fill the selection with the sky colors.** Using the Gradient tool, create a gradient of sky colors from dark to light through the selected sky area, keeping the dark at the top and the light at the bottom. Experiment with the position of the start and stop points of your gradient line. You work a gradient by clicking once to start the gradient, then, keeping the mouse button depressed, move to a new spot where the gradient will end, then release. The gradient will blend over that distance.

✳ **Adjust the new sky color and tone.** Use the Hue/Saturation and Brightness/Contrast controls to make the sky look natural. You can also change the opacity of the layer to control its density—this can be a very effective way to make the sky look natural.

✳ **Add noise to the sky.** The computer colors used for the sky fix are smooth and won't look very photographic. Enlarge a section of the photo so you can see the grain in the non-sky part of the photo and add some noise to the sky colors to match (Add Noise is in Filters>Noise). Usually, you need to set the grain very low and you might need to add a slight Gaussian blur to it to make it match the rest of the photo. Just compare it to the details nearby from the original photo.

Printing the Panoramic

Once you complete your panoramic image, you'll want to print it out on your Epson printer. This is not a problem except that you need to have long paper. You can buy Epson photo-quality paper in rolls that are precut to a standard panoramic size of 8.3 x 23.4 inches (21 x 59 cm).

When you print, you need to tell your printer the type of paper and the size you are using. Obviously, a very big panoramic will take some time to print. Be careful to support the paper going into and coming out of the printer so it does not fold or crease, which will damage your photo.

JACK REZNICKI

A COMMERCIAL PRO

Joyce Tenneson

J ack Reznicki knows the power of a good print. As a commercial photographer, he says his imagery may get him the jobs, but the prints from his Epson close the deal.

Since opening his own studio in 1980, Jack has worked with some of the biggest companies in the world, including Canon USA, Visa, American Airlines, Reader's Digest, The Wall Street Journal, Johnson & Johnson, and many more in the Fortune 500. He has shot several Time Magazine covers, authored books and articles, won awards too numerous to name, and is currently the President of the Professional Photographers of America (PPA). To say the least, he knows what he is talking about.

Jack loves his Epson printers. But it isn't the normal list of reasons—amount of control, the long-lasting inks, the exquisitely engineered papers, or the beautiful machinery—that warrants this adoration, although those reasons alone are more than enough to love these printers. He

loves the printers because of peoples' reactions to the richer colors and the depth of his prints. Since he started printing on Epson printers, his portfolio books him a higher percentage of jobs than ever before, and if it comes down to him and another photographer, he can count on his beautifully printed portfolio to give him the edge.

Another reason Jack loves his Epson printers is the fast turnaround time to make a beautiful print. In a conventional darkroom, it wasn't unusual for one print to take two or three hours to perfect. Just one print! But with Epson printers, a gorgeous, portfolio-worthy print takes just a few minutes. In fact, Jack has printed entire portfolios in a single day in order to get them out to prospective clients. It has never been easier or more satisfying to print gorgeous images.

Whether he's shooting on location, in the studio, teaching, or writing, Jack knows that his prints will always perform to his high standards and communicate his imagery in the most beautiful and fluid way possible.

You can view Jack Reznicki's work on his website: www.reznicki.com

Ink jet printers require some minimal mainte-nance for best performance.

CHAPTER 11

Caring for your Printer

The life of your printer can be extended with cleaning and other regular maintenance.

There is no question that the expensive, graphic arts ink jet printers, which often have similar printing specifications to much lower-priced units, will print a volume of prints every day for a much longer period of time than a value-priced printer. As always, you get what you pay for. However, if you only print a few photos per week, you probably don't need a high-priced printer designed for the graphic artist or wedding photographer, who crank out lots of photos.

Of course, you may want to upgrade your printer before it wears out if new technology offers something valuable to you. Printers with several "black" inks (as Epson calls them, though they are really black plus gray inks), for example, are a great benefit for anyone doing black-and-white printing. So, if you want to do a lot of that type of printing and only have a four- or six-color printer, that type of printer may be an excellent investment.

Regardless of your printer, there are some things you can do to keep your Epson printer working at its best. Your printer's manual will cover much of this in more detail than I can do in this book, but I will give you hints on maintaining your printer.

On and Off

Normally, when you turn a printer off from its power switch, the printer head parks in a very specific place to protect the head from drying out. However, if you just turn off a power strip, the printer head may or may not be parked properly. This can lead to the head drying out and clogging.

If you are using the printer on a daily basis, you can just leave it on. You should turn the printer off if it is not going to be used for a few days. This allows it to park its heads, which maintains them properly.

Another thing that you can do to ensure your printer keeps making good prints is to keep making prints! A printer does its best when used regularly. That keeps the inks flowing through the head and makes the nozzles stay clog free. At the very least, make a print every week or two (if not more often) to keep the printer functioning well. Enjoy your printer; if you don't need a specific print, experiment with new ideas or just print something up to see what it looks like as a print. This will help you develop your craft for making prints and keep your printer functioning well.

Print Head Cleaning

Sooner or later, though, you will probably deal with a clogged head. Ink droplets are very, very small and require very small openings—openings that can clog and block the flow of ink to the paper. This can happen from ink drying out, poor quality non-brand ink, and from storing inks too long.

When clogging occurs, you'll typically see a couple of symptoms:

✳ Streaks of ink or lines of white where ink did not print.

✳ Off-color images because of one color missing from the mix.

When these things occur, it's time to clean. How often you need to clean depends on environmental conditions, but a quick cleaning never hurts at any time. On Epson printers, you can initiate cleaning in two ways: on the printer or through software.

There is a cleaning button on the front of the printer (check your manual for exact placement). Hold it down for three seconds and the unit will start a cleaning cycle.

For heavy-duty cleaning of a serious clog, it is best to use the head-cleaning utility in the software. The software gives you more flexibility and you can do a nozzle check to see how well the cleaning went. You get to this utility through the printer driver. Right-click the printer icon in the Windows taskbar (or get to it through the Start menu, Settings, and Printers) and select Head Cleaning (you can also go to the maintenance tab in the printer driver). On a Mac, open the File menu and

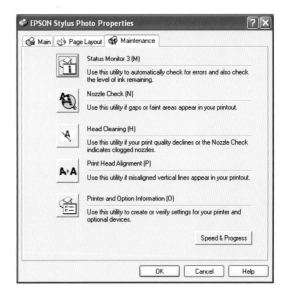

Refer to the Maintenance tab in Windows and the Utility option on Mac to troubleshoot problems and perform regular equipment checks.

choose Page Setup or Print. Then click the Utility and Head-Cleaning buttons in that order.

Follow the on-screen instructions, then use the Nozzle Check command to be sure the head is clean. Multiple cleaning passes will help, especially if the printer has been sitting for many weeks. Epson printers will start a deeper cleaning cycle on the third time you tell the system to clean. This will use a lot of ink during the cleaning.

With either technique, the printer

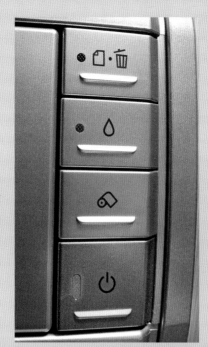

will make a bit of noise while it works—this is normal. The green power light will flash while it is working. Do not turn the printer off while it is cleaning its heads.

Once it is done, use the head-cleaning utility to check the nozzles on the head. Click on Print Nozzle Check Pattern, then Print. Check your page

A clogged print head (below left) can exhibit as poor or no ink coverage from a specific color. The ink drop icon (left, second from top) initiates the cleaning mechanism for a clogged head.

Use a large, clean, camel hair brush to occasionally clean dust specks and paper particles out of the printer's paper path.

Keeping Cartridges Fresh

I know some folks think that an unopened ink cartridge can sit unaffected for a long time. This is not true, especially if you are using pigment-based inks. After a while, those pigments settle in the liquid and you may find that your print quality declines. Epson cartridges now have an expiration date; pay attention to that and replace your cartridges for the best results.

Epson has added tiny glass beads to their inks to help stir the pigments while the cartridge is moving. Pick up the cartridge and give it a shake every once in a while if the printer has not been used (when the printer is in use, the cartridges get enough "shaking").

when it comes out. If the printed pattern is nice and solid with no gaps or lines, the head is clean. If it is streaky, try cleaning again.

If you do this a few times and you still see streaking, you can try turning the printer off and letting it sit overnight. According to Epson, this allows dried ink to soften. Then try cleaning again. You may also find that the old ink cartridge just isn't helping. You can install a new one and the heads may clean better.

Clogged heads can come from using non-Epson ink cartridges. Epson has a very high standard of ink quality, and independent cartridges will not necessarily meet Epson's standards. This can be a big problem because the head is built into the printer and cannot be easily cleaned if clogged by bad ink. To minimize clogging problems, follow the guidelines given above and only buy quality ink.

General Maintenance

A printer gets dusty over time. To keep it at its peak, you may find it helpful to clean it a few times a year. This is a pretty simple thing to do, but be sure to disconnect both the power plug and the computer cable before starting.

Use a soft brush to clean dust and dirt from the sheet feeder. You can use the same brush inside the printer, but avoid the gears. A can of compressed air can be used to get rid of dust and debris, but never shake it or get the nozzle too close to moving parts. Clean ink out of the inside of the printer with a soft, slightly damp (not wet) cloth. Use a soft, slightly damp cloth on the outside as well.

Never use any solvents or oils, especially cleaners with alcohol, as this can damage the plastic. Don't use the cleaning sheets that sometimes come with printing papers as these can actually cause problems, including jamming inside the printer.

Dan Steinhardt

Troubleshooting Common Printer Problems

Driver problems

It is possible to have your driver fail to work properly in any number of ways. If you get odd things happening to your print, from poor color to improper alignment of the image on the paper, you may have driver problems (don't confuse it with head clogging, though). Removing and reinstalling the driver can help. In addition, it is always a good idea to check Epson's website every once in a while to see if a new, improved driver or software patches have been posted.

White lines or missing colors

These are classic signs of a clogged print head (although missing colors may be a sign of a low ink cartridge). Clean the head, use multiple passes if necessary, and check the nozzle print pattern (see your manual).

Banding or splotchy colors

Be sure you have the right paper and driver setting. Some non-Epson papers can print very poorly in this way. In addition, some papers have a "right" side and a "wrong" side. Printing on the "wrong" side may cause odd ink patterns on the photo. If the paper is inserted correctly, and the driver setting is right, try cleaning the print head or check to see if you need a new ink cartridge.

Faint or low contrast prints

This can come from a number of sources, including clogged ink heads. However, most often, this problem is caused by the use of the wrong printer driver setting and/or the wrong paper. This can also be caused by old ink cartridges or old paper.

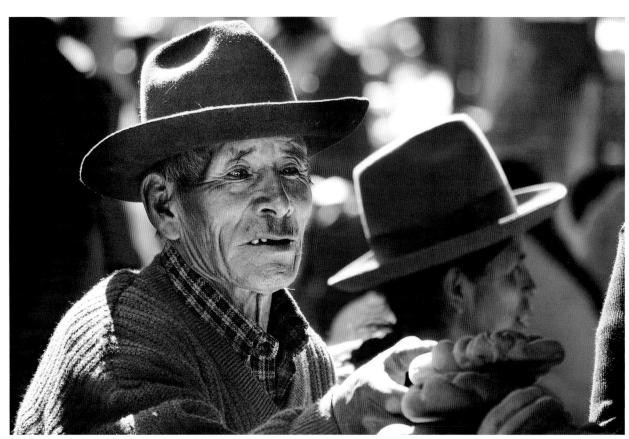

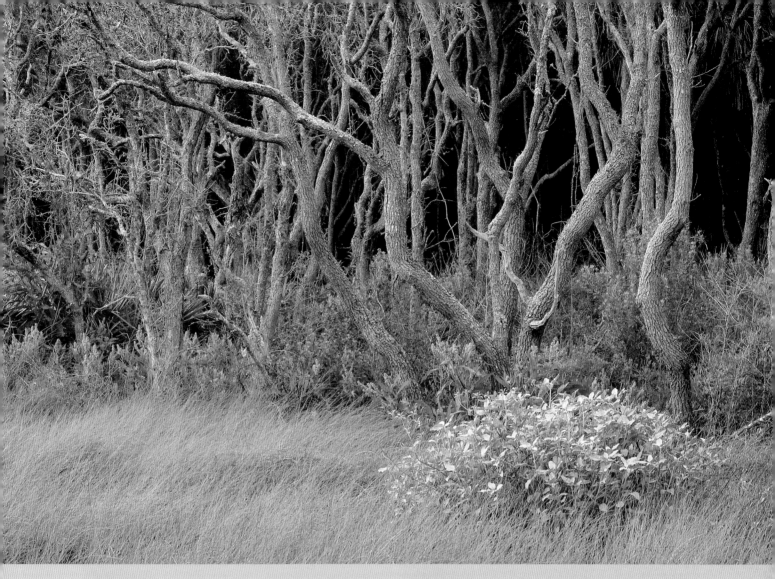

Printing seems slow

5 Check your image size. Big, high-resolution images require RAM and hard-drive space to print. Be sure you have enough of each. You may need to add both, but RAM is especially important.

Prints look grainy

6 This is usually a function of the image, so check to see that you aren't seeing grain or digital noise in your image file (see Grain and Noise Management in Chapter 8 for more information). This can also be an issue of trying to print a file that has a low image resolution.

Check the manual

7 I know—no one ever reads the manual. Yet, Epson manuals have excellent troubleshooting guides that are specifically for your printer.

Run a printer check

It can be useful to know if the printer or the computer is the source of any problem. Turn off the printer and computer, and then disconnect the printer. Hold down the maintenance button (check your manual) and at the same time push and release the power button. Keep holding the maintenance button until the green power light flashes.

The printer will print a test page. If it prints okay, then the problem is most likely in the computer or in the cable connection.

GLOSSARY

acuity
The definition of an edge between two distinct elements in an image that can be measured objectively.

Adobe Photoshop
Professional-level image-processing software with extremely powerful filter and color-correction tools. It offers features for photography, graphic design, web design, and video.

Adobe Photoshop Elements
A limited version of the Photoshop program, designed for the avid photographer. The Elements program lacks some of the more sophisticated controls available in Photoshop, but it does have a comprehensive range of image-manipulation options, such as cropping, exposure and contrast controls, color correction, layers, adjustment layers, panoramic stitching, and more.

artifact
Information that is not part of the scene but appears in the image due to technology. Artifacts can occur in film or digital images and include increased grain, flare, static marks, color flaws, noise, etc.

backup
A copy of a file or program made to ensure that, if the original is lost or damaged, the necessary information is still intact.

bracketing
A sequence of pictures taken of the same subject but varying one or more exposure settings, manually or automatically, between each exposure.

brightness
A subjective measure of illumination. See also, luminance.

buffer
Temporarily stores data so that other programs, on the camera or the computer, can continue to run while data is in transition.

card reader
Device that connects to your computer and enables quick and easy download of images from memory card to computer.

CCD
Charge Coupled Device. This is a common digital camera sensor type that is sensitized by applying an electrical charge to the sensor prior to its exposure to light. It converts light energy into an electrical impulse.

chrominance
A component of an image that expresses the color (hue and saturation) information, as opposed to the luminance (lightness) values.

chrominance noise
A form of artifact that appears as a random scattering of densely packed colored "grain." See also, luminance and noise.

CMOS
Complementary Metal Oxide Semiconductor. Like CCD sensors, this sensor type converts light into an electrical impulse. CMOS sensors are similar to CCDs, but allow individual processing of pixels, are less expensive to produce, and use less power. See also, CCD.

CMYK mode
Cyan, magenta, yellow, and black. This mode is typically used in image-editing applications when preparing an image for printing.

color balance
The average overall color in a reproduced image. How a digital camera interprets the color of light in a scene so that white or neutral gray appear neutral.

color cast
A colored hue over the image often caused by improper lighting or incorrect white balance settings. Can be produced intentionally for creative effect.

color space
A mapped relationship between colors and computer data about the colors.

CompactFlash (CF) card
One of the most widely used removable memory cards.

complementary colors
In theory: any two colors of light that, when combined, emit all known light wavelengths, resulting in white light. Also, it can be any pair of dye colors that absorb all known light wavelengths, resulting in black.

compression
A method of reducing file size through removal of redundant data, as with the JPEG file format.

contrast
The difference between two or more tones in terms of luminance, density, or darkness.

critical focus
The most sharply focused plane within an image.

cropping
The process of extracting a portion of the image area. If this portion of the image is enlarged, resolution is subsequently lowered.

download
The transfer of data from one device to another, such as from camera to computer or computer to printer.

dpi
Dots per inch. Used to define the resolution of a printer, this term refers to the number of dots of ink that a printer can lay down in an inch.

DPOF
Digital Print Order Format. A feature that enables the camera to supply data about the printing of image files and supplementary information contained within them. The printer must be DPOF compatible for the system to operate.

dye sublimation printer
Creates color on the printed page by vaporizing inks that then solidify on the page.

EXIF
Exchangeable Image File Format. This format is used for storing an image file's interchange information.

file format
The form in which digital images are stored and recorded, e.g., JPEG, RAW, TIFF, etc.

firmware
Software that is permanently incorporated into a hardware chip. All computer-based equipment, including digital cameras, use firmware of some kind.

focal plane
The plane on which a lens forms a sharp image. Also, it may refer to the sensor plane.

focus
An optimum sharpness or image clarity that occurs when a lens creates a sharp image by converging light rays to specific points at the focal plane. The word also refers to the act of adjusting the lens to achieve optimal image sharpness.

FP high-speed sync
Focal Plane high-speed sync. Some digital cameras emulate high shutter speeds by switching the camera sensor on and off rather than moving the shutter blades or curtains that cover it. This allows flash units to be synchronized at shutter speeds higher than the standard sync speed. In this flash mode, the level of flash output is reduced and, consequently, the shooting range is reduced.

gigabyte (GB)
Just over one billion bytes.

gray scale
A successive series of tones ranging between black and white, which have no color.

hard drive
A contained storage unit made up of magnetically sensitive disks.

histogram
A graphic representation of image tones.

icon
A symbol used to represent a file, function, or program.

image-processing program
Software that allows for image alteration and enhancement.

interpolation
Process used to increase image resolution by creating new pixels based on existing pixels. The software intelligently looks at existing pixels and creates new pixels to fill the gaps and achieve a higher resolution.

ISO
From ISOS (Greek for equal), a term for industry standards from the International Organization for Standardization. When an ISO number is applied to film, it indicates the relative light sensitivity of the recording medium. Digital sensors use film ISO equivalents, which are based on enhancing the data stream or boosting the signal.

JPEG
Joint Photographic Experts Group. This is a lossy compression file format that works with any computer and photo software. JPEG examines an image for redundant information and then removes it. It is a variable compression format because the amount of leftover data depends on the detail in the photo and the amount of compression. At low compression/high quality, the loss of data has a negligible effect on the photo. However, JPEG should not be used as a working format—the file should be reopened and saved in a format such as TIFF, which does not compress the image.

LCD
Liquid Crystal Display, which is a flat screen with two clear polarizing sheets on either side of a liquid crystal solution. When activated by an electric current, the LCD causes the crystals to either pass through or block light in order to create a colored image display.

lossless
Image compression in which no data is lost.

lossy
Image compression in which data is lost and, thereby, image quality is lessened. This means that the greater the compression, the lesser the image quality.

luminance
A term used to describe brightness. It can also be used as luminance noise, which is a form of noise that appears as a sprinkling of black "grain." See also, brightness, chrominance, and noise.

Mac
Macintosh. This is the brand name for computers produced by Apple Computer, Inc.

megabyte (MB)
Just over one million bytes.

megapixel
A million pixels.

memory card
A solid state removable storage medium used in digital devices. They can store still images, moving images, or sound, as well as related file data. There are several different types, including CompactFlash, SmartMedia, and xD, or Sony's proprietary Memory Stick, to name a few. Individual card capacity is limited by available storage as well as by the size of the recorded data (determined by factors such as image resolution and file format). See also, CompactFlash (CF) card, file format.

midtone
The tone that appears as medium brightness, or medium gray tone, in a photographic print.

moiré
Occurs when the subject has more detail than the resolution of the digital camera can capture. Moiré appears as a wavy pattern over the image.

noise
The digital equivalent of grain. It is often caused by a number of different factors, such as a high ISO setting, heat, sensor design, etc. Though usually undesirable, it may be added for creative effect using an

image-processing program. See also, chrominance noise and luminance.

pan
Moving the camera to follow a moving subject. When a slow shutter speed is used, this creates an image in which the subject appears sharp and the background is blurred.

PC
Personal Computer. Strictly speaking, a computer made by IBM Corporation. However, the term is commonly used to refer to any Windows computer.

pincushion distortion
A flaw in a lens that causes straight lines to bend inward toward the middle of an image.

pixel
Derived from picture element. A pixel is the base component of a digital image. Every individual pixel can have a distinct color and tone.

plug-in
Third-party software created to augment an existing software program.

RAM
Stands for Random Access Memory, which is a computer's memory capacity, directly accessible from the central processing unit.

RAW
An image file format that has very little or no internal processing applied by the camera. It contains 12-bit color information, a wider range of data than 8-bit formats such as JPEG.

RAW+JPEG
An image file format that records two files per capture; one RAW file and one JPEG file.

resolution
The amount of data available for an image as applied to image size. It is expressed in pixels or megapixels, or sometimes as lines per inch on a monitor or dots per inch on a printed image.

RGB mode
Red, Green, and Blue. This is the color model most commonly used to display color images on video systems, film recorders, and computer monitors. It displays all visible colors as combinations of red, green, and blue. RGB mode is the most common color mode for viewing and working with digital files onscreen.

saturation
The degree to which a color of fixed tone varies from the neutral, grey tone; low saturation produces pastel shades whereas high saturation gives pure color.

thumbnail
A small representation of an image file used principally for identification purposes.

TIFF
Tagged Image File Format. This popular digital format uses lossless compression.

tripod
A three-legged stand that stabilizes the camera and eliminates camera shake caused by body movement or vibration. Tripods are usually adjustable for height and angle.

TTL
Through-the-Lens, i.e. TTL metering.

USB
Universal Serial Bus. This interface standard allows outlying accessories to be plugged and unplugged from the computer while it is turned on. USB 2.0 enables high-speed data transfer.

viewfinder screen
The ground glass surface on which you view your image.

Wi-Fi
Wireless Fidelity, a technology that allows for wireless networking between one Wi-Fi compatible product and another.

INDEX